whiskerslist

Loading...

whiskerslist
the kitty classifieds

Angie Bailey

RUNNING PRESS
PHILADELPHIA · LONDON

ISBN 978-0-7624-4981-1
Library of Congress Control Number: 2013938430
E-book ISBN 978-0-7624-5060-2

9 8 7 6 5 4 3 2 1
Digit on the right indicates the number of this printing

Cover and Interior Design by Jason Kayser
Edited by Jennifer Leczkowski
Typography: Arial and Times New Roman

Running Press Book Publishers
2300 Chestnut Street
Philadelphia, PA 19103-4371

Visit us on the web!
www.runningpress.com

Acknowledgments

This book would never have come to be without the daily inspiration of my three feline fuzzbutts, Saffy, Cosmo, and Phoebe. They allow me to write the craziest things about them and expose their deepest and darkest secrets—you know, like their affinity for watching me shower and do the rest of my bathroom business.

A huge thanks to my editor at Running Press, Jennifer Leczkowski, whose cheerful communication, positive demeanor, and helpful guidance made the entire publishing experience a dream. Thank you to Matthew Frederick for the brilliant cover concept and Jason Kayser for the fabulous design. Much gratitude to Suzanne Wallace for her enthusiasm as the book's publicist.

Thanks to all my cat blogging buddies—your friendship and support mean the world to me. Thanks to Dusty Rainbolt for assuring me I could do this and Nicky Westbrook for always listening to my crazy ideas and sharing ridiculous amounts laughter with me for more than 25 years.

I have endless appreciation and respect for my agent, Sorche Fairbank of Fairbank Literary Representation. She took a chance on me and generously shared her patience and knowledge with this literary newbie. *Whiskerslist* would not be what it is without her collaboration and willingness to dissect and discuss the most ridiculous cat-related scenarios with me. She's the best.

Lastly, the support and encouragement of my family has been immeasurable. They gave me quiet space to write, told me they were proud of me, and kept laughing even when they were sick to death of looking at silly cat photos. My infinite love and gratitude goes to John, Katie, Ben, Mom, Harlan, and Maureen. Thank you for loving me and letting me be weird.

Introduction

Have you ever wondered what your cats are up to when left alone? Forget the expense of a nanny cam—I have proof. Despite their best efforts at keeping the whole operation private, we've uncovered evidence revealing what *really* happens the minute you've left the house. Lack of opposable thumbs be damned! Before your car's reached the bottom of the driveway, the cat's already fired up your laptop and logged onto whiskerslist.com, the hub for online felines looking to:

- find a meaningful relationship, missed connection, or quick hookup.

- sell that sock you were certain the dryer ate, relocate that favorite tossed toy, or traffic your used Q-tips.

- weigh in on discussions about two-timing toms, post-kittens weight loss, and stupid human tricks.

- rant about the repulsive neighbor dog that keeps humping the mailman or the other cat who keeps stinking up the litter box.

- locate a class to learn tips for great hiding spots, master the art of looking away while being photographed, or discover creative ways to reuse hairballs.

- find support groups for where they can fly their mixed-breed freak flag and break compulsive behavior like cord chewing and string swallowing.

- hire a lawyer to go after the bastards who keep changing your brand of litter, post embarrassing photos of you in costume, or worse, or engage in feline genital mutilation.

. . . and that's just what's been posted in the last hour.

The whiskerslist cat community is steadily gaining members, and as more of these fuzzy little wi-fi weasels plug in passwords, we humans stand to lose more and more control. I shudder to imagine the day I happen across an ad for "female human for sale: passable lap size, leaves OK amount of food unattended on kitchen counter, shoes moderately stinky, buys crappy toys . . . make an offer." That time is not that far away, friends.

What to do? Read this book carefully and become familiar with the type of activity that's happening right under your nose. Frequently change the wi-fi password and monitor your cat(s), looking for signs of suspicious behavior. It also might not be a bad idea to start buying better cat toys.

With urgency, I beg you to start reading now, but do it behind closed doors . . . they're watching.

The first rule of catfight club . . .

Date: 2013-06-18 8:52PM EDT

(Reply to this post)

Neutered male indoor cat looking to sneak out at night and take out some aggression with males in similar circumstances. Are you tired of being bullied by the dog and then scolded when you try to fight back? Sick of having your treats stolen by the other cat when you're not looking? Let's meet in local alleys for some serious catfighting! Claws out, muthaf**kas! They may have taken away the balls, but they can't take away the brawls!

Only contact me if you are serious about REAL fighting and keeping it on the down-low. There WILL be rules, and the first rule of catfight club is YOU DO NOT TALK ABOUT CATFIGHT CLUB.

- Location: Wilmington, DE
- ID: 74859879345

Female in heat looking for quick hookup

Date: 2013-05-18 3:18AM CDT

Reply to this post

Can you hear me howl? I'm rolling around and rubbing myself on the sofa thinking of you. Absolutely no strings attached. You won't be disappointed. Meeeooow!

- Location: Jackson, MS
- ID: 36468134

Reply to this post Rate Flag

So I went on a blind date with this hot DSHF last week and she took me back to her place and then spent half the night in the litter box while I was left with her SIX kittens! WTF??
<wtfdate> 04/12/13 05:02

> Run!! <stud123> 04/12/13 05:17
>
>> For real. What are you, a babysitter? <nippp> 04/12/13 05:18
>>
>>> I know, right? Those kittens were all over me like I was some kind of freaking wet nurse!
>>> <wtfdate> 04/12/13 05:25
>>>
>>>> Ain't NO tail worth that. <stud123> 04/12/13 05:28
>
> Hey—I've been in a wonderful relationship with a female who is a new mom. They rarely get breaks from those kittens. Cut her some slack! <motherlover> 04/12/13 05:32
>
>> Hey <motherlover>, go back to the vet asap and ask for your balls back. <nippp> 04/12/13 05:34

Free: empty TP roll, excellent condition

Date: 2013-05-13 9:09PM PDT

(Reply to this post)

Freshly emptied, quality name brand TP roll, pristine and ready for play. I already have five, otherwise I'd keep it myself. Free to good home.

- Location: Ashland, OR
- ID: 9465464251

Class Action Lawsuit is no LOL

Date: 2013-02-10 7:18AM PST

(Reply to this post)

If your photo has been stolen and illegally used for LOLcat purposes, we can get you a settlement.
You are not alone. Many cats have already come forward. Contact us at the law offices of Stripey, Boots, and Pawzlowski. We can help you get the compensation you deserve for losing your dignity.

- Location: Fresno, CA
- ID: 28340930808044

Help me crash dog show?

Date: 2013-01-04 9:03PM EST

Reply to this post

Looking for a group of pranksters to help me crash the Westminster Dog Show. I have a jar of fleas and a gallon size ziplock of my own poop. I'm even willing to shave myself and streak during Best in Show. Any joiners?

- Location: New York, NY
- ID: 483497874

Looking for sexy, purebred pussycat to rock my world

Date: 2013-02-18 9:12PM CST

(Reply to this post)

My name is Hector and you want me. I am an 8-year-old gray-and-white mancat who likes to party big-time. You are a trim, purebred, medium- to longhaired hottie with a free spirit and no kittens or fleas. Rhinestone collars, colored kitty nail caps a plus. Come over to my place and let's share a drink from my bathtub faucet.

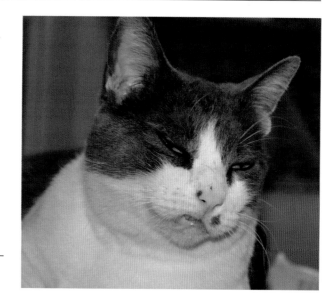

- Location: Fort Worth, TX
- ID: 834957993

Loaf models needed for local bread-baking class

Date: 2012-09-17 7:09PM EDT

(Reply to this post)

Local Community Ed is looking for cats to model various loaf shapes for new fall bread-baking class (especially looking for mini loaves and extra-large, sourdough-loaf shapes). No experience necessary, all shapes and sizes welcome to apply. Long-bodied cats that can model croissants and cinnamon rolls will be given extra compensation.

- Location: Hickory, NC
- ID: 473929980

Loking for new nip conextion

Date: 2013-04-12 1:11AM EDT

(Reply to this post)

Hey. My nip conextion moved to Cincinati and I need sum. Can you help a brotha out? I am also in serous need of sum Flavor Blasted Beef treats. The kind thar are shped like stars and triangls. Do you now what Im talking about? I will meet you anywhere. Thx.

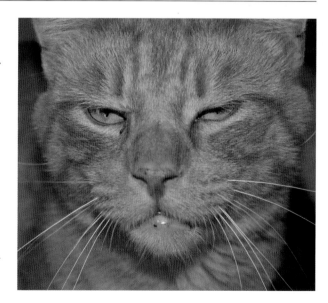

- Location: Louisville, KY
- ID: 379879879

roanoke whiskerslist > community > groups

Anger Management Group Looking 4 New Members

Date: 2013-03-14 5:23PM EDT

(Reply to this post)

Friends and family tired of you flying off the
the handle? Learn techniques that will help you stop
before rabbit-kicking the face off humans who
insist on dressing you in ill-fitting sailor suits and
stupid Santa hats. Pick up tips from experienced
members so you can refrain from biting the necks of
other cats who don't respect your personal space.
Let's not be angry TOGETHER.

- Location: Roanoke, VA
- ID: 48799702

Looking for cute female to hang out with

Date: 2013-03-01 8:10PM CST

(Reply to this post)

My name is Hector. I am an 8-year-old gray-and-white mancat who likes a variety of indoor and outdoor activities. You are a moderately trim female (crossbreed / minor post-litter pudge, OK) with absolutely no fleas. If you have kittens, I can help line up a sitter. Let's hang out and see what happens.

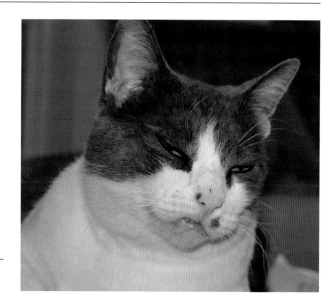

- Location: Fort Worth, TX
- ID: 834957993

Holiday Depression? Join Our Supprt Group

Date: 2012-12-03 2:19AM EST

(Reply to this post)

The holidays are a particularly difficult time, what with the neverending parade of holiday cat clothing, antlers, and hats. And then the humans just laugh at us. They think it's "funny" and "cute." And they take photos, post them on the computer, and use them for Christmas cards. It's downright degrading. And those lucky ones whose humans don't subject them to this godawful routine taunt us mercilessly. Come be with other cats dealing with the same issues and support each other as you get through this not-so-merry time of year. Together, we just might have a voice.

- Location: Allentown, PA
- ID: 83493298793

GENITAL MUTILATION VICTIM? HELP IS JUST A CALL AWAY

Date: 2013-01-30 10:12PM MST

(Reply to this post)

Were your genitals mutilated in a "neuter" or "spay"?

You may not be able to get your genitals back, but I can get you the compensation you rightly deserve for this atrocity.

I've won hundreds of genital mutilation cases and will be happy to meet with you for a FREE CONSULTATION.

Mittens McMullen, Attorney at Law

"Extending My Claws . . . So You Don't Have To."

- Location: Bozeman, MT
- ID: 783948987

Tasteful Boudoir Photos

Date: 2013-01-07 2:56PM MST

(Reply to this post)

Next month is Valentine's Day and there's still time to schedule a boudoir photo shoot for your sweetheart! We specialize in tasteful poses in a variety of settings / backgrounds. Professional grooming prior to the shoot is included. Contact us for pricing.

- Location: Phoenix, AZ
- ID: 7483499379797

Reply to this post Rate Flag

What's the best thing you've stolen off the kitchen counter? <countercruiser> 04/18/13 04:02

An entire stick of butter. <1sticker1> 04/18/13 04:06

Did you eat it all??? <countercruiser> 04/18/13 04:08

No, it was confiscated after five or six bites. <1sticker1> 04/18/13 04:13

Humans are such buzzkills. <countercruiser> 04/18/13 4:18

Got that right. <1sticker1> 04/18/13 04:23

Some salami. I hid under the sofa and savored every bite. <carni4> 04/18/13 04:12

Score!! I took some bacon once. <mmmbacon> 04/18/13 04:23

Hot dogs!!!!!!! <catluvsdogs> 04/18/13 04:28

Ever licked a pot roast pan? Drippings FTW!! <drippy24> 04/18/13 04:08

No, I did lick a lasagna pan once. That was pretty good. <vegout12> 04/18/13 04:15

Who are you, Garfield? <drippy24> 04/18/13 04:20

No. I just like tomato sauce. <vegout12> 04/18/13 04:26

Are you one of those flaky vegetarians? <drippy24> 04/18/13 04:34

I like hummus too. <vegout12> 04/18/13 04:40

Freak. <drippy24> 04/18/13 04:43

I like to lick fresh newspaper. <lickylicky> 04/18/13 04:20

WTF??? <countercruiser> 04/18/13 04:26

Freak. <drippy24> 04/18/13 04:27

How about Thanksgiving crap left out? <drippy24> 04/18/13 04:50

Turkey! <countercruiser> 04/18/13 04:52

One word: gravy. <drippy24> 04/18/13 04:55

Cranberry Sauce! <vegout12> 04/18/13 04:57

Freak. <drippy24> 04/18/13 04:58

Way to ruin Thanksgiving. <countercruiser> 04/18/13 04:59

OK. I'm really not a freak. How about pizza boxes? <vegout> 04/18/13 05:08

Now you're talkin. <countercruiser> 04/18/13 05:12

That's the $hit. <drippy24> 04/18/13 05:13

You know how you can nudge the lid of the box open? <vegout> 04/18/13 05:15

Yeah, yeah. <drippy24> 04/18/13 05:17

And the smell is just amazing. Seriously, you can't stop drooling. <vegout> 04/18/13 05:19

Keep going . . . <countercruiser> 04/18/13 05:23

Awwww yeah. <drippy24> 04/18/13 05:24

And then you lean your head inside the box. <vegout> 04/18/13 05:26

Yesssssssss. <countercruiser> 04/18/13 05:27

I'm about to explode! <drippy24> 04/18/13 05:28

Damn, those are some good green peppers! <vegout12> 04/18/13 05:30

Seriously? WTF? <countercruiser> 04/18/13 05:31

Freak. <drippy24> 04/18/13 05:32

Wanted: Female

Date: 2013-03-12 6:23PM CST

(Reply to this post)

My name is Hector. I am an 8-year-old gray-and-white mancat who likes whatever you like. You are a thin/fat/purebred/crossbred/stray/one-eyed/three-legged female with or without fleas, mites, ticks, kittens, or mange. Give me a yowl—I can be there in ten minutes.

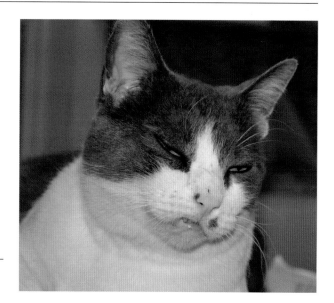

• Location: Fort Worth, TX
• ID: 834957993

no Risk OPPORTUNITY

Date: 2013-01-30 10:12PM EST

(Reply to this post)

If I could show you a No Hype No BS Impoosible to Fail way to generate 100+ QUALITY rodents per month guarenteed month after month, would u be willing to take the risk? There are other claims out there, but my program (trademark pending) is the real deal. Looking for 5 motivated invididuals looking to change their life.

P.S. If u do not generate 100+ QUALITY rodents per month within 3 mnths, you will receive everything u invested. Contact for more info . . .

Thanks,
Felix

- Location: New York, NY
- ID: 108849794

What has been seen cannot be unseen

Date: 2012-11-19 1:10PM MST

(Reply to this post)

Yesterday I saw the neighbor's ratty-assed brown dog humping the mailman's leg. Call me old fashioned, but that blatant canine demonstration of a sexual advance toward a human appendage was filthy. Why can't stupid dogs control themselves? As if I wasn't already sick to death of the drooling, incessant yapping, and crapping all over my yard (and sometimes eating it!). Now I have to see THIS? Pass the eye bleach!!! Geez.

- Location: Tucson, AZ
- ID: 723487368468

Lost: one used sweat sock

Date: 2012-09-17 3:08PM CDT

(Reply to this post)

One really great, well-seasoned sock has gone missing

White(ish), gray on toe and heel, small hole on bottom, crunchy spots

Hid under entertainment center and now gone

Only had it for a couple of weeks, and miss it terribly

Small reward offered

- Location: Des Moines, IA
- ID: 28478937

Hellooo ladies

Date: 2013-01-29 6:17PM EST

(Reply to this post)

SLEEK AND SHINY ALL FOR YOU. LOOK INTO MY EYES AND SEE WHAT PLEASURE AWAITS. I DO NOT DISAPPOINT. NOT ALL AT ONCE, LADIES. LOL.

No cougars plz.

- Location: South Jersey
- ID: 903748979

got milk?

Date: 2013-07-28 1:19PM EDT

(Reply to this post)

You probably like milk just as much as me. It's hard to come by and sometimes you just have to do what you have to do to get some. I've figured out a surefire method for getting humans to hand over the moo juice. I am available for lessons to teach you how to act like/look like a REAL human baby. It works and I'm not even kidding. I know humans are kind of slow and it's not that hard to fool them but please DON'T TRY THIS ON YOUR OWN. It's harder than it looks. Contact me to set up a one hour lesson, include approximation of dress size.

- Location: Florence, SC
- ID: 3849239474

Polite Jewish South Philly boy looking for likeminded travel partners

Date: 2013-06-17 2:10PM EST

(Reply to this post)

Brand new kosher deli open in Fishtown. Maury AKA "Bootsy" says there's some nice pastrami.
Anybody wanna travel with me to check out the dumpster? Looking for easy going travel
partners. No kvetching.

- Location: Philadelphia, PA
- ID: 739294980

Need help with an intervention?

Date: 2013-01-30 10:39AM PST

(Reply to this post)

If you have a loved one who has hit rock bottom, I am an experienced counselor and can help you plan and facilitate an intervention. I have assisted in interventions for addictions to catnip (fresh and dried), tape (invisible, packing, and duct), and humping inanimate objects (clothes, blankets, stuffed animals), as well as toy/treat hoarding situations. I also assist in follow-up recovery. Contact me and we can discuss the details.

- Location: Elko, NV
- ID: 83784798394

Found: shark toy inside blue slip-on shoe

Date: 2013-01-11 6:03PM EST

(Reply to this post)

Small grey shark found inside blue slip-on shoe. Is this yours? If not claimed in one week, will add to my private collection.

- Location: Raleigh, NC
- ID: 6739292

Need cats for performance art exhibit

Date: 2013-06-27 8:37PM EDT

(Reply to this post)

Looking for cats of all kinds interested in participating in the performance art exhibit, "Cats Who Stare at Walls." Contact Twinkie at PolydACTyl for details.

- Location: Lancaster, PA
- ID: 30287978434

Need entertainments at your kitten's next party? I'm your guy!

Date: 2012-10-02 1:19PM EDT

(Reply to this post)

My name is Uncle Ravioli and I am available to entertain at your kittens birthday parties and Bar Mitvahs. My specialty is sculpting rodents out of canned food and playing Hide the Hairball. Kittens love me! Message me for details.

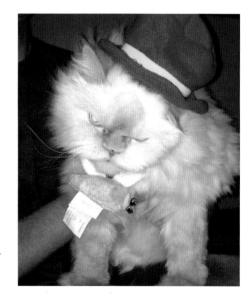

- Location: Buffalo, NY
- ID: 287499379

Male Libido Enhancer

Date: 2013-05-19 11:20PM CDT

(Reply to this post)

Do u miss that randy feeling u experienced before being neutered? Felerect® is the top-rated feline libido enhancer, known to produce performance enhancement and heighten pleasure. Contact us for a free trial and then get on the prowl!

Felerect® side effects may include spraying, strong urine odor, aggression, hairballs, excessive shedding, rancid fish-breath, frequent gacking, sweaty paws, chronic itchiness, dry cough, wet sneezes, frequent urination, tongue distention, nipple redness, compulsive grooming, acute ass dandruff, extreme jumpiness, alternating diarrhea and excessive straining while using litterbox, dander sensitivity, gander sentitivity, moodiness, extended third eyelid disorder, buildup of ear gunk, eye discharge, bald patches, tail twitchiness, excessive drooling, room-clearing gas, nasal discharge, uncontrolled purring, anal gland leakage, and the potential of wandering for miles, following the scent of a female in heat.

- Location: Oklahoma City, OK
- ID: 834239479

driving teacher for hire

Date: 2013-08-08 10:06AM CDT

(Reply to this post)

want the freedom to travel far and fast WITHOUT having to ride in a carrier? no worries. I will teach you how to drive. i am way better than toonces and will let you take the wheel on day 1. very reasonable fees. automatic only.

Testimonial: "Patches was patient and never yelled at me. I only hit one squirrel. He was delicious."

—Bitsy M., Bowling Green

- Location: Bowling Green, KY
- ID: 276899764

Death Cat Available for Home Visits

Date: 2013-08-19 3:09PM PDT

(Reply to this post)

Other cats claim to predict deaths, but I am the real deal. I've worked at several nursing homes in the San Diego area and come with impressive references from the families of the deceased. Have an ailing family member? Hire me to come over for a visit. Five minutes with your loved one, and I'll be able to tell you if they'll still be around for the holidays.

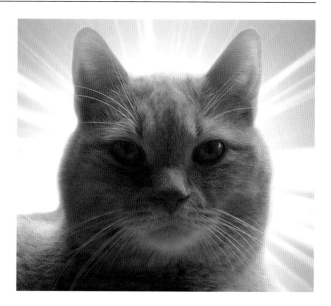

- Location: San Diego, CA
- ID: 7847583458

The nakeder the better . . .

Date: 2013-02-09 12:08AM PST

(Reply to this post)

I will be in town next Tuesday and am looking for a female Sphynx to meet up for an evening of intense bathing and uninhibited fun. Must be COMPLETELY smooth. Email me with pic (assuming you look like the hottie pictured here), and I'll return the same.

- Location: Chico, CA
- ID: 923840808

Talk show looking for cats involved in baby-daddy drama and more

Date: 2013-06-12 9:10AM PDT

(Reply to this post)

Looking to track down your baby-daddy tom? He says the litter "ain't his," but you'll know for certain when we tell you the results of the on-air paternity test! We are looking for guests of all breeds and backgrounds, especially females with multiple litters from different fathers, two-timing toms and their ladies, and crossbreeds living as purebreds wanting to come out to their friends and new families. Also looking for separated littermates looking for surprise reunions.

- Location: Los Angeles, CA
- ID: 834239479

Need entertainments at your night before the neuter party? I'm your guy!

Date: 2012-10-02 1:25PM EDT

(Reply to this post)

My name is Ravioli and I am available to entertain at your wild adult-only parties. My specialty is finding the hottest tail in town and escorting them to your rockin' party. I can also locate top notch nip "refreshments" and operate a video camera. Complete discretion guaranteed. Message me for details.

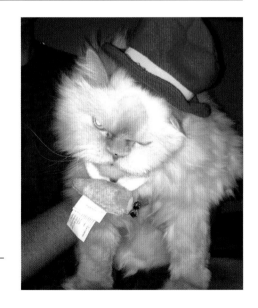

- Location: Buffalo, NY
- ID: 287499380

Zen Master Hairbala to Speak at Event Center

Date: 2013-05-19 2:09PM CDT

(Reply to this post)

Well respected Zen master Hairbala will speak on enlightenment and peacefully living among our brothers and sisters who sometimes steal our food, attack us when we sleep, and mock us as we sit in the carrier.

Afterwards, Hairbala will lead an outdoor meditation on the west side of the building, during afternoon sun.

"There may be flea, but there is no flee. I AM HERE NOW."

—Hairbala

- Location: Tulsa, OK
- ID: 18349329744

(Reply to this post) (Rate) (Flag)

Baskets vs. boxes. Discuss. \<spotsnotstripes\> 02/05/13 3:10

 Boxes sometimes have lids. Bonus for hiding. \<sneakypete\> 02/05/13 3:14

 But baskets come in different shapes. Round baskets rule! ☹. \<basketcase5\> 02/05/13 03:18

 Do laundry baskets count? If so, then baskets. \<4paws4\> 02/05/13 03:13

 But only if they have laundry in them. Otherwise their too big. \<spotsnotstripes\> 02/05/13 03:17

 You're both morons. Baskets suck. \<kibblerelf\> 02/05/13 03:22

 ^^Jackass. \<spotsnotstripes\> 02/05/13 03:25

 I calls em like I sees em. \<kibblerelf\> 02/05/13 03:28

 Me too and I call you a Jackass \<spotsnotstripes\> 02/05/13 03:35

I like the sound of the hair dryer. Is that weird? \<feelthenoiz\> 02/05/13 05:10

 yes. \<goodmewz\> 02/05/13 05:13

 are you sure you're a cat? \<bast4ever\> 02/05/13 05:15

 Of course. For some reason that sound just captures me. \<feelthenoiz\> 02/05/13 05:18

 I don't get it, but to each his own. \<goodmewz\> 02/05/13 05:21

I hide under the bed when that thing comes out. <bast4ever> 02/05/13 05:22

Nutjob. you need to be in the Psych forum. <giblet> 02/05/13 05:17

No need to be rude. <feelthenoiz> 02/05/13 05:19

<u>Link to Psych. forum.</u> <giblet> 02/05/13 05:21

<u>Link to Psych. forum.</u> <giblet> 02/05/13 05:22

<u>Link to Psych. forum.</u> <giblet> 02/05/13 05:23

<u>Link to Psych. forum.</u> <giblet> 02/05/13 05:24

<u>Link to Psych. forum.</u> <giblet> 02/05/13 05:25

<u>Link to Psych. forum.</u> <giblet> 02/05/13 05:26

Message received! STOP! <feelthenoiz> 02/05/13 05:28

<u>Link to Psych. forum.</u> <giblet> 02/05/13 05:29

Maxine that hangs out at Maplewood Park is a HOBAG <duchess777> 02/05/13 10:16

Aw, I like her. <gingertom> 02/05/13 10:17

I'll bet you do. <duchess777> 02/05/13 10:19

What? She's friendly. <gingertom> 02/05/13 10:20

I saw her getting friendly with you in the parking lot. <duchess777> 02/05/13 10:23

Jealous much? <gingertom> 02/05/13 10:27

Hardly! <duchess777> 02/05/13 10:30

I saw that skank with two toms in the bushes. <tabbygrrl> 02/05/13 10:22

Surprised? Not. I heard she's not even spayed. <duchess777> 02/05/13 10:25

All I know is she better not come near my Petie. <tabbygrrl> 02/05/13 10:28

Too late honey. <maxine4u> 02/05/13 10:35

WHAT? You're gonna get it! <tabbygrrl> 02/05/13 10:36

That's what Petie said last night. 02/05/13 10:37

NOT FUNNY! <tabbygrrl> 02/05/13 10:38

☺ <maxine4u> 02/05/13 10:39

Gamers Needed

Date: 2013-07-01 4:03PM PDT

(Reply to this post)

Do you like to swat game pieces or hide puzzle pieces? Join our group! We welcome all levels of skill and competition. We meet Friday nights underneath Maurice's porch. Whether you enjoy the strategy of chess moves or the casual slidy-action of checkers or Scrabble, we have something for everybody.

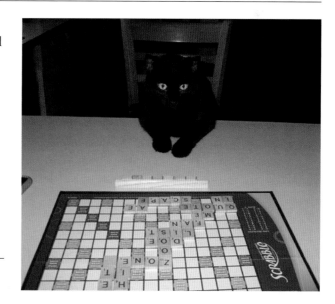

- Location: Bakersfield, CA
- ID: 67384672

HUGE MULTI CAT SALE!!!

Date: 2013-06-19 2:10PM EDT

(Reply to this post)

TOYS (maybe you like cloth toys not filled with catnip, but I do NOT)

GENTLY USED LITTER BOXES!!

BOXES—ALL SIZES!!

SMELLY SHOES!!

CURTAINS (BARELY CLIMBED)

EVERYTHING MUST GO!!! In alley behind Save-a-Lot

- Location: Fredericksburg, VA
- ID: 108849794

Cat Moving Service

Date: 2012-12-19 4:35PM MST

(Reply to this post)

Another cat constantly jacking your spots?
We will come in and physically move them (more
than once if we need to). You won't get blamed
and the cat will (eventually) get the message.
***Pay by cat weight.

- Location: Logan, UT
- ID: 98789796768

fort wayne whiskerslist > personals > strictly platonic

Wingman Wanted

Date: 2013-06-15 1:12PM EDT

(Reply to this post)

Looking to score some serious tail? My buddy
just got fixed so I'm looking for a new wingman to
accompany me to some back alleys tonight. Must
be social, a good BS artist, and smooth with
the ladies. Hit me up bro.

- Location: Fort Wayne, IN
- ID: 73492799

Poet wants kinderd spirit

Date: 2013-07-10 6:10PM PDT

(Reply to this post)

Sensitive, philispophical cat looking for the right female. I love long slinky walks outside, deep conversatons about the meaning of lives and writing poems. You are a female, age doesn't matter. If our soles are meant to be we will know it, reconize it when we meet.

- Location: Berkeley, CA
- ID: 48739457973

Sing to me again
about the leafs in fall
and how you rescued me
when i fell hard and fast
from that gas staton sign.

I will sing to you
about the flowrs in spring
and how I folowed you
into the corn crib on my
cousin Stinkys farm
even tho you told me to
leave you alon.
Love is forever.

Need entertainments at your kittyshower? I'm your guy!

Date: 2012-10-02 1:32PM EDT

(Reply to this post)

Expecting a litter? My name is Ravioli and I am available to tastefully entertain at your very special kittyshower. My specialty is creative and fun shower games like "pin the kittens on the teats," and organizing a "guess the sex of the kittens" pool. I am also available for gentle massages and back-of-the-head licking. Message me for details.

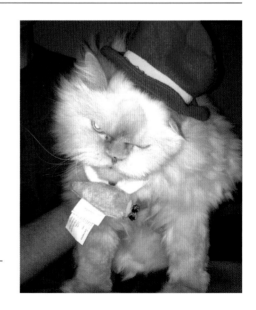

- Location: Buffalo, NY
- ID: 287499381

Cooking With Rodents

Date: 2013-07-28 12:02PM EDT

So you've caught a varmint and you just don't feel like eating it raw. What next? In Cooking With Rodents (BYOR*), Chef Sassy Monroe will show you lots of simple recipes to create flavorful entrees and sides such as Rat Rat Ratatouille, Slice Dice Mice Rice, Buttery Mice Cream Dream, Spicy Vole Profiteroles, Hoison Hamster Rollups, Gerbil Gumbo, 5-Layer Rodent Bake, and Field Mouse Frittata. Class also covers recipe scaling, feeding a crowd, and quick substitutions.

*Bring your own rodent.

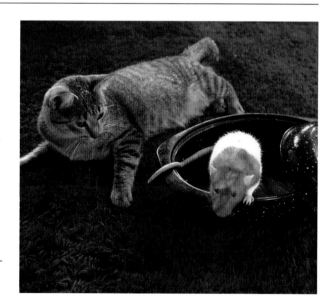

- Location: Lynchburg, VA
- ID: 3874832994

FORMER MUSIC VIDEO MODEL AVAILABLE FOR HIRE

Date: 2013-02-28 9:12PM PST

(Reply to this post)

Attention Bands: Recognize me? Yes, that's right.
I was the hottie rubbing her butt on top of the
carpeted cat condo in the "In Heat of the Night"
music video by Krazy Katzen. It's been a few years,
but I've still got it and am available for more music
video or modeling gigs. Need a mature, totally metal,
hot (still unspayed) female? Drop me a line.

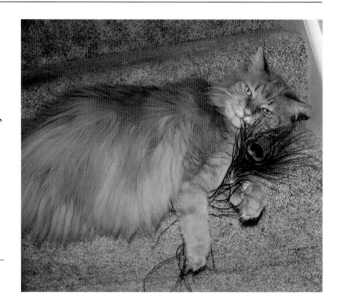

- Location: Las Vegas, NV
- ID: 8493957979

Tickets available for new play "Creative Loafing"

Date: 2013-02-28 9:09PM PST

(Reply to this post)

This is the hottest ticket in town and I have two front row seats to sell for next Friday's performance. "Creative Loafing" is a two-hour visual extravaganza featuring ten cats taking turns lying in various positions (some sleeping, some cleaning, some simply staring blankly into space). You'll laugh, you'll cry, you'll be thinking about those positions for days after the curtain falls.

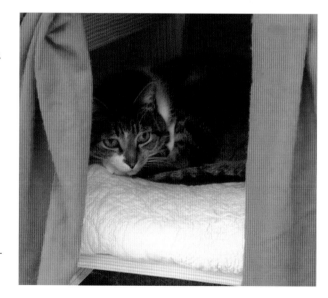

- Location: Spokane, WA
- ID: 2928374973794

Lose that holiday flab with PaunchBusters®!

Date: 2013-01-03 4:15PM EST

(Reply to this post)

Too many festive table scraps and stolen counter fare? Are you finding your post-holiday paunch is preventing you from sliding in and out of the tight spots where you used to play and sleep? Are *they* laughing at the way your belly swings when you run in at mealtimes?

Worry not! With our personalized meal plans and a regular exercise regimen, you'll be squeezing under sofas and into dresser drawers again in no time!

PaunchBusters®: It's Not a Diet, It's a LIFESTYLE

- Location: Annapolis, MD
- ID: 3749899743

kansas city whiskerslist > personals > rants & raves

Message to Weirdo-Poly Box-Squatter

Date: 2013-09-05 7:10PM CDT

(Reply to this post)

Some jackass is peeing in my litter box! The pee smells like funky skunk roadkill, and the freaky paw prints look polydactyl. If this is you, keep your six-toed, stinky piss out of my box. And maybe get your UTI ass to the vet and get some Clavamox.

- Location: Kansas City, MO
- ID: 834957993

Want to sue for Disturbance of the Peace?
HELP IS JUST A CALL AWAY

Date: 2013-04-18 12:10PM MDT

(Reply to this post)

Tired of being talked to in high-pitched tones?

Sick of being called "Baby," "Kitty Boo Boo," and "Fluffbutt" when your given name is Maurice?

Have you had it with being summoned with mouth-clicking and kissy noises?

I've won hundreds of invasion of privacy and disturbance of the peace cases and will be happy to meet with you for a FREE CONSULTATION.

Mittens McMullen
Attorney at Law

"Extending My Claws . . .
So You Don't Have To."

Call for a FREE
Consultation

555-CLAW

- Location: Bozeman, MT
- ID: 783953879

Sweetie . . . I don't fall in love

Date: 2012-12-28 2:10PM MST

(Reply to this post)

Hello Flagstaff, I'm going to be in town for New Year's and am looking for a fun male to hang out with for the week.

I like long naps, snuggles, rolling in dirt, and jerky.

NO COMMITMENT! NO RISK! (Spayed, on Advantage, updated on all shots)

I'm in town from time to time and don't have time for anything serious. Just want to have some fun, doggy-style.

- Location: Flagstaff, AZ
- ID: 28939497

Comfortable Pizza Box for Sale

Date: 2012-11-21 9:56AM CST

(Reply to this post)

This is a really great pizza box and is just one week old. The grease spots are still pretty good. I've licked some of them but not all. Also this is a great nap box with a week's worth of great memories. Man, I hate to part with it but I need the cash. Make me an offer. You pick up.

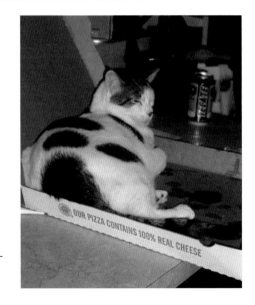

- Location: Dallas, TX
- ID: 924890776

Toilet training

Date: 2013-04-27 9:18AM EDT

(Reply to this post)

Tired of walking around in a litterbox that's been pooped in lord knows how many times while you wait for someone to scoop your deposits? I can help! With a little training, you can pee and poop and flush it away immediately! Or not flush . . . I GUAR-AN-TEE the humans will have disposed of it before you need it again. The squat-n-squirt method of toilet urination is relatively easy to learn and once you have that down, we'll move on to the crouch-n-crap. PLEASE NOTE: I WILL NOT TAKE RESPONSIBILITY IF YOU FALL IN. YOU WILL BE ASKED TO SIGN A WAIVER PRIOR TO LESSONS.

- Location: Charlotte, NC
- ID: 2483979934

Need volunteers to pee on stuff

Date: 2013-02-27 1:16PM CDT

(Reply to this post)

Mr. Socks' humans got a new kitten that won't leave him alone. Socks has requested a group to come over and pee all over their stuff. They work all day so he thought noon would be best. Next Monday. Meet at the water meter on the side of Socks house. We'll start there and work our way in.

- Location: Jonesboro, AR
- ID: 1382094803

Attention sink lovers: Need a space to yourself for an hour or two?

Date: 2013-04-10 12:10AM EDT

(Reply to this post)

Nice sink space sanctuary for rent, $2/hr (or open to trade for 3 oz. cans of Fancy Feast, Gravy Lovers Chicken Feast flavor, no other flavors please)

Cool porcelain

Great for naps or for just being alone with your thoughts

Occasional drip from faucet—water-softened, perfect for light sipping

Dark, quiet bathroom

No noisy kitten traffic

Available most weekdays from 8:30 to 5:00

• Location: Macon, GA
• ID: 6754547811

Who else likes dog food?

Date: 2013-03-31 8:40PM EDT

(Reply to this post)

Looking for a friend who wants to hang out and eat dog food with me. My friends all think Im wierd and Im tsick of them making fun of me. Lets meet up between 8 and 9 am or 7 and 8 pm (when the dog is being walked) I have plenty of kibble if you can bring canned (preffer beef pate flavors). I really like Beggin Strips to. Cool.

- Location: Hilton Head, SC
- ID: 7485683043

TIRED OF BEING IN THE DARK???!? Be blind no more! Call me!

Date: 2013-01-03 4:15PM CST

(Reply to this post)

Want to look out the window but are thwarted by shades or blinds? I can help. I will show you patented paw techniques for moving shades or blinds so you can crawl behind or underneath. After you've mastered that, we'll move on to no-fail methods of chewing, bending, or breaking plastic blinds (strategies for wood and metal blinds covered in follow-up visit, if needed). Don't be denied a view of local wildlife and sunbeams. Call me today!

(Extraction of cat inexpertly wedged between horizontal blinds = extra.)

- Location: Normal, IL
- ID: 98439797493

I will ghost write you're book

Date: 2013-08-03 1:13AM EDT

Reply to this post

Looking for a ghost writer to write you're 9 lives memoir? Look no farther, you're story could be the next Hollywood blockbuster let me help you write it. I am a grate editor and pretty good at cober design too message me for some examlpes.

- Location: Flint, MI
- ID: 1834929797

Attention gourmands: Tasty, unusual, and hard-to-get foods for sale. Rotating menu.

Date: 2013-05-29 2:10PM CDT

(Reply to this post)

Are your tastes a league above the average feline's? Don't want to be limited to hooves and feathers in a can (what else did you think Friskies is made of?) I am the answer to your needs. No begging, no byproducts, just real food. How? I take food RIGHT from the plate. As the hoomans are eating even. This is GOOD, FRESH, GOURMET food and I have new stuff every night. Message me for the catch of the day. First come, first served.

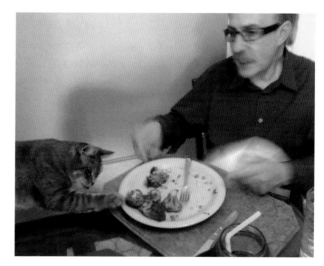

- Location: St. Joseph, MO
- ID: 384983432

Reply to this post Rate Flag

What are some good ideas for a cute little indoor girl to get a bit of exercise? \<callie\> 08/10/13 11:02

I like to wrestle with the other cats in the house. \<tom_tom18\> 08/10/13 11:05

But sweetie, I'm an only kitty. ☹. \<callie\> 08/10/13 11:07

Must get lonely. \<tom_tom18\> 08/10/13 11:10

Honey, you have no idea . . . \<callie\> 08/10/13 11:14

I'll bet your real cute too. \<tom_tom18\> 08/10/13 11:17

Calico. Hot pink collar. \<callie\> 08/10/13 11:20

Nice. I've always been a sucker for calicos \<tom_tom18\> 08/10/13 11:26

FREE SIAMESE WEB CAM GIRLS CLICK HERE \<camz4u\> 08/10/13 11:28

How about you? \<callie\> 08/10/13 11:29

Gray tabby. Ear points. Wish you could see my guns. I run up and down the stairs a lot. \<tom_tom18\> 08/10/13 11:32

Yum. \<callie\> 08/10/13 11:36

GET A ROOM. \<samuelk\> 08/10/13 11:39

I don't know. I'm kinda likin this. <jonesy> 08/10/13 11:41

Weirdo. @callie message me. <tom_tom18> 08/10/13 11:44

Anyone else training for the Iron Cat competition? <felixdacat> 08/11/13 12:25

Yeah. That timed tree climbing is killing my ass. <gotnip00> 08/10/13 12:27

Dude. I almost lost a claw last week. <felixdacat> 08/10/13 12:29

Ohh . . . you guys sound really fit. <callie> 08/10/13 12:33

@callie, are you in the competition too? <felixdacat> 08/10/13 12:37

Little ol me? Nah. I'd love to watch you big strong mancats though . . . <callie> 08/10/13 12:39

Well sure. Maybe you can watch me practice tomorrow. <felixdacat> 08/10/13 12:42

Not tonight? (pouts, flattens ears) <callie> 08/10/13 12:44

Uh, I think we can make that happen <felixdacat> 08/10/13 12:47

Tell me about yourself. DSH? Number of toes? How long is your tail? <callie> 08/10/13 12:28

This is supposed to be a post about the competition! <gotnip00> 08/10/13 12:32

Wanna see a pic? <felixdacat> 08/10/13 12:34

Ooooh, yeah <callie> 08/10/13 :36

I'm outta herre <gotnip00> 08/10/13 12:37

Jealous. @callie message me. <felixdacat> 08/10/13 12:43

Anybody have suggestions for building my back leg muscles? <wild_one> 08/11/13 01:15

Jumping. Lots of jumping. <biteme> 08/11/13 01:18

Oh, I love a tom with strong back legs. <callie> 08/11/13 01:19

I work out every day. My back legs are BUFF. <biteme> 08/11/13 01:22

I don't know if I believe you. I might have to see for myself. <callie> 08/11/13 01:24

@callie, I'm trying to get some help here. Can you take it to a different forum? <wild_one> 08/11/13 01:26

@callie, I don't mind if you stay. <biteme> 08/11/13 01:28

I started this thread in the FITNESS forum and I need some real help! <wild_one> 08/11/13 01:31

@callie, wanna take it offline? <biteme> 08/11/13 01:32

Sounds good to me. Meet me in the parking lot behind the Endzone Bar. <callie> 08/11/13 01:33

Wait. Isn't that where the neutered girly toms hang out? <biteme> 08/11/13 01:34

@callie?? Are you a dude? WTF?? <biteme> 08/11/13 01:36

@callie?? Are you still there?? <biteme> 08/11/13 01:37

Yes . . . <callie> 08/11/13 01:38

Well, I'm not interested. Freak. <biteme> 08/11/13 01:39

I am. Message me @callie. <wild_one> 08/11/13 01:40

@wild_one are you kidding me?? <biteme> 08/11/13 01:43

@wild_one??? <biteme> 08/11/13 01:43

@biteme I've got needs—sue me! <wild_one> 08/11/13 01:46

You NEED to meet me now. <callie> 08/11/13 01:53

You two deserve each other. <biteme> 08/11/13 01:55

@biteme See you at tree-climbing tomorrow? <wild_one> 08/11/13 01:58

See you then. <biteme> 08/11/13 01:59

Crossbreed support group meets Thursday nights

Date: 2013-07-16 5:10PM PDT

(Reply to this post)

Don't be ashamed you're not purebred. Our weekly meetings offer a safe space to shed labels and embrace your true beauty. Just because "they" call you a pedigree-poser doesn't mean you have to slink into the shadows.

- Location: Anaheim, CA
- ID: 9424302834

PRIDE

We're mixed, we're here, get used to it.

FUN PILLOWS 4 U : THINK HOLIDAZE!!!

Date: 2012-11-15 11:10AM EST

(Reply to this post)

THE HOLIDAYS ARE COMMING. I MAKE
FUN DECORATIVE PILLOWS OUT OF
RECYCLED CHIKEN OF THE SEA PINK
SAMMON PACKETS. I WILL BE AT THE
HOLIDAY EXPO BUT YOU CAN ALWAYS SEND
ME A MASSAGE AND I WILL MAKE ONE FOR
YOU. THESE MAKE UNIQUE CRISMAS
GIFTS. OCCAISIONALLY TUNA PACKETS
AVAILABLE UPON REQUEST.

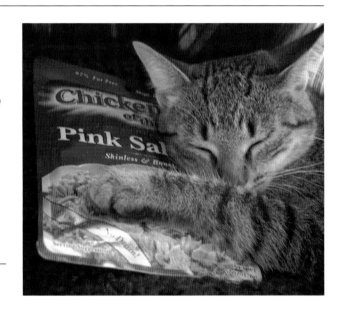

- Location: North Jersey
- ID: 84573958649

I SEE YOU

Date: 2013-07-12 8:11PM CDT

(Reply to this post)

Hey jackass labradoodle from down the street: don't think I don't see you crapping in my yard and eating my garbage. I'm always in the window and I'm taking notes. Do I look amused? Consider this a warning.

- Location: La Crosse, WI
- ID: 3238987974

I like to dress up.

Date: 2013-01-14 1:04AM PST

(Reply to this post)

I am a homebody, neutered male crossdresser (with a large collection of designer wigs) looking for my soul mate. I don't like to go out much. I mostly like to dress up at home and run up and down the stairs. Message me with photos and tell me about yourself.

"Don't you ever let a soul in the world tell you that you can't be exactly who you are."

—Lady Gaga

- Location: Redding, CA
- ID: 38479239

Cats Needed to Pose For Painting

Date: 2013-05-10 2:30PM CDT

(Reply to this post)

Local artist looking for cats to pose for commissioned Cats Playing Poker painting. Must be able to sit still (and awake) for long hours, and refrain from chewing the cards. Please reply with headshot and number of hours you can sit without a litter box break.

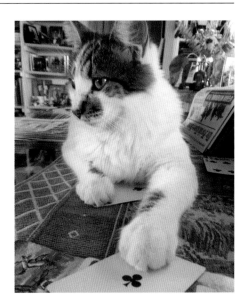

- Location: Biloxi, MS
- ID: 373487397947

Lot of toy mice for sale. Varying conditions. Must take all.

Date: 2013-04-27 9:18AM EDT

(Reply to this post)

I'm moving and have to get rid of 17 suede toy mice (non-catnip). The trouble is my roommate is one of those EBI guys (everything but the inside), so about ⅓ of them are at best barely shells, and mostly innards (think of them as naked, haha). Still fun though. Naked mice are ½ price, though buyer must take the entire lot. I posted pics of both so you know what I'm talking about. Call me—let's deal!

- Location: Hartford, CT
- ID: 2483979934

HUMAN HANDWRITING CLASS

Date: 2013-02-08 10:06AM CST

(Reply to this post)

LEARN TO COPY YOUR HUMAN'S HANDWRITING AND REAP THE BENEFITS:

***LEAVE NOTES FOR OTHER HUMANS, ASKING THEM TO PLEASE FEED THE CAT EXTRA, LEAVE THE PANTRY DOOR OPEN, AND CANCEL VET APPT.

***ADD EXPENSIVE TREATS AND TOYS TO THE SHOPPING LIST.

MUST BRING YOUR HUMAN'S WRITING SAMPLE TO CLASS.

SPACE AND LITTERBOXES ARE LIMITED. ACT NOW.

- Location: Nashville, TN
- ID: 3980808908

Quality Control Agents Needed

Date: 2013-02-08 6:45PM MST

(Reply to this post)

Quality control agents needed at plastic hanger factory. Now hiring all three shifts. We are a union factory (Hanger Workers Local #246). Must have a full set of teeth and be able to stay on task. Cats with oral fixation need not apply. Last year we were fined by the US Hanger Association because more than half of our hangers went out chewed to hell and we had to hand 50 cats their walking papers that day. Excessive chewing WILL NOT be tolerated!

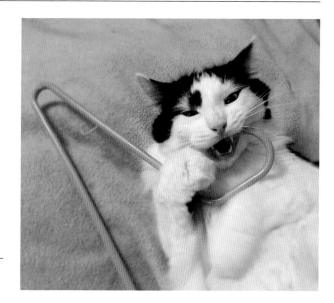

- Location: Albuquerque, NM
- ID: 458789797979

!!CHAT WITH LIVE CATS NOW!!

Date: 2013-03-01 12:10AM CST

(Reply to this post)

BORED? MESSAGE US TO TALK TO
REAL LIVE SEXXXY LOCAL SINGLE
MALE AND FEMALE ADULT CATS WHO
ARE WAITING TO TALK TO YOU NOW.
24-HRS. CHARGES MAY APPLY.

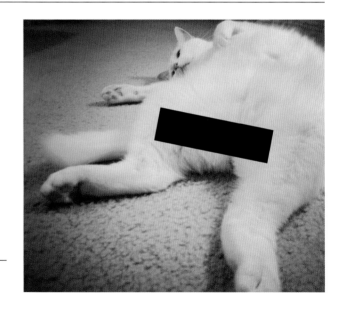

- Location: Pensacola, FL
- ID: 736878823

Tippy Cup for something nice

Date: 2013-03-05 10:18PM CDT

(Reply to this post)

This is a great plastic cup. tips super easy and holds alot of liquids. you will enjoy tipping it. I am looking for anything comperable. maybe five or six still-wrapped straws or a toothbrush? open to all offers.

- Location: Kirksville, MO
- ID: 82893848308044

Gams like these don't come easy

Date: 2013-04-15 6:52AM EDT

(Reply to this post)

Want strong, sexy legs? One word: Powerkneading.
Powerkneading is the latest craze in the cat fitness community.
You'll start with light, simple fabrics and work your way
up to wools and burlap, all the time increasing your reps and
speed. Contact Feline Fitness for class schedules.

- Location: Jacksonville, FL
- ID: 583749794754

****TABLE FOOD THIEF FOR HIRE***

Date: 2013-08-10 7:01PM CDT

Reply to this post

NINJA FAST!!

PRECISE!!

KITCHEN TABLES!!

COUNTERS!!

CUPBOARDS EXTRA (CUPBOARDS WITH NO HANDLES EXTRA-EXTRA)!!

WHY DENY YOURSELF THE GOOD STUFF?

I RETAIN 10% OF STOLEN FOOD, EXCEPT FOR ANYTHING CRUNCHY (I JUST HAD THREE TEETH EXTRACTED)

- Location: Amarillo, TX
- ID: 73492799

Are you experiencing Pain and Suffering from Physical Harassment? HELP IS JUST A CALL AWAY

Date: 2013-05-02 10:45AM MDT

(Reply to this post)

Have you been snatched up and manhandled when you're trying to sleep?

Forcefully removed from laundry baskets of clothing?

Have you been shoved into a cramped crate and driven to a barbarian who stabs you with needles?

Stalking, harassment, kidnapping, unlawful imprisonment, and intent to harm are all taken seriously by a court of law—this doesn't have to be your cross to bear. I've won pain and suffering damages in hundreds of such cases and will be happy to meet with you for a FREE CONSULTATION.

Mittens McMullen Attorney at Law

"Extending My Claws . . . So You Don't Have To."

Call for a FREE Consultation

555-CLAW

- Location: Bozeman, MT
- ID: 783953879

9th Annual Taste of Nip Festival

Date: 2013-06-19 3:10AM MDT

(Reply to this post)

Announcing the 9th annual Taste of Nip Festival held in Skippy's basement next Saturday and Sunday. Try several varieties of nip, including California Gold, Mellow Medley, Backyard Bud, and Mystic Meowza.

Skippy will again feature his 75-gallon psychedelic black light tropical fish tank!

Free admission with one bag of crunchy treats or anything with extra gravy.

- Location: Denver, CO
- ID: 2483979934

Personal Alarm Service

Date: 2013-02-16 12:12PM CST

(Reply to this post)

While you peacefully nap, rare (normally annoying) insomniac cat will alert you of not-to-be-missed events like:

• Can opener noises

• Fresh bag or box arrivals

• Interesting birds at the feeder

• Human food left unattended

• Another cat jacking your favorite toy

YOU WON'T MISS A THING!! CALL ME!!!

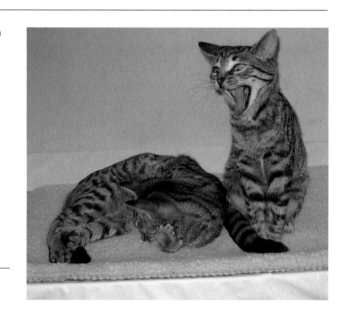

• Location: Laredo, TX
• ID: 863874686

polydactlyl looking for same for texting buddy

Date: 2013-07-10 2:35PM PDT

(Reply to this post)

frnds w/reg paws r such slw txtrs. LOL. I wnt 2 meet anothr poly who cn txt as fst as me. LOL. If we get alng, mayb take to nxt lvl. LOL JKJK. hope 2 hear from u 2nite. text me maybe. LOL MOL JKJK TTYL

- Location: Los Angeles, CA
- ID: 8893495739475

(Reply to this post) (Rate) (Flag)

OK, cats . . . here's your Haiku prompt for the week: "Smell" <paws4poems> 06/05/13 10:17

> <mom2six> 06/05/13 10:32
> I awake from sleep
> A wonderful scent greets me
> Your butt in my face
>
> <tab123> 06/05/13 12:17
> Empty tuna cans
> The kitchen garbage calls me
> Cheeseburger wrapper
>
> <nipnut555> 06/05/13 02:19
> You think I'm asleep
> When you steal my catnip mouse
> But I can smell you (jackass)
> **Ooops . . . guess that's more than 7 syllables in that last line =^.^=
>
> <scratch2011> 06/05/13 03:09
> I scratch in the box
> Lower into position
> I must concentrate

<tab123> 06/05/13 03:45
Dead mouse rolled away
Beneath the dark, dark sofa
Wish for longer reach
THIS HAPPENED TO ME, FOR REAL. TOTALLY SUCKS!!

<felixx> 06/05/13 03:52
Scratching and smelling
Mystery spot on carpet
Breathe with open mouth

<nomnom2> 06/05/13 03:57
Wafting from outside
Neighbor cat pissed on my house
The reek is tenfold
Stinky neighbor cat: If you are reading this, consider it a warning!! I'm serious!!

<scratchy$> 06/05/13 04:04
Ripe with teenage sweat
Tennis shoes left by the door
Are my Siren song

Advanced Yoga Class

Date: 2013-07-10 9:18AM PDT

(Reply to this post)

Cats are natural stretchers, but in the advanced yoga class, you'll learn poses to keep you limber and flexible well into your Senior Meaty Bits years:

Dumpster Downward Dive Pose (seen here)

Slowly Choking Bird Pose

Kitchen Counter Reach Pose

Smother the Baby Pose

Class meets Friday mornings at the La Jolla Shores.

- Location: La Jolla, CA
- ID: 92348997974

Tired of Being Set Up With the Wrong Type???

Date: 2013-04-29 11:34PM CDT

(Reply to this post)

Online dating can be such a disaster. Can you really trust that cats really are who they say they are? And well-meaning friends just don't get it. No one wants to be set up on another blind date! Well I get it. My name is Maxine and I have been a successful feline matchmaker for three years. I will meet with you and really get to know who YOU are. I'll bathe you, sit alongside you in the litter box, and even share nap and playtime. Then I'll set out to find your perfect match. My success rate is 98% and I know I can find the right one for you. True love is right around the corner.

- Location: Topeka, KS
- ID: 59808093444

(Reply to this post) (Rate) (Flag)

Looking for a Christmas gift idea for my girlfriend. <santa_cat> 12/10/12 6:12

 Fancy collar? <jewlz> 12/10/12 06:18

 She doesn't wear collars. <santa_cat> 12/10/12 06:25

 Garfield bobblehead: <u>click here</u> <bobble3> 12/10/12 06:32

 Tacky. No thanks. <santa_cat> 12/10/12 06:36

 Garfield bobblehead: <u>click here</u> <bobble3> 12/10/12 06:42

 No bobbleheads! <santa_cat> 12/10/12 06:46

I only have $1. What's a good gift? <budgetboy> 12/10/12 08:15

 Get a JOB! <tabby2tone> 12/10/12 08:20

 How about a ball? <fuzzy_feet> 12/10/12 08:24

 How about you get some BALLS and get a job?? <tabby2tone> 12/10/12 08:30

 Garfield bobblehead: <u>click here</u> <bobble3> 12/10/12 08:48

 I only have $1. <budgetboy> 12/10/12 08:50

 Look at my post below <bobble3> 12/10/12 08:57

Garfield bobbleheads $1 <u>click here</u> <bobble3> 012/10/12 08:32

SWEET! <budgetboy> 12/10/12 09:02

Do not buy bobbleheads from @bobble3. They are crap. <budgetboy3> 12/10/12 10:05

Garfield bobblehead: <u>click here</u> <bobble3> 12/10/12 10:12

Have you seen your site? They look like they're made out of old cans and cardboard. <budgetboy> 12/10/12 10:14

Garfield bobblehead: <u>click here</u> <bobble3> 12/10/12 10:12

Would you stop already?? They aren't even worth the hairball I just hacked up. <budgetboy> 12/10/12 10:14

Garfield bobblehead: <u>click here</u> <bobble3> 12/10/12 10:12

You're impossible. <budgetboy> 12/10/12 10:14

Piano cat bobblehead: <u>click here</u> <bobble3> 12/10/12 10:12

Replacement bell?

Date: 2013-05-24 2:20PM EDT

(Reply to this post)

Does anybody have an extra jingle bell for
this kind of ball? It's my favorite, and the bell broke.
Boo! Thank you.

- Location: South Bend, IN
- ID: 343940098

I LIKE BIG MUTTS AND I CANNOT LIE!

Date: 2013-04-12 9:13PM MDT

(Reply to this post)

do u know any big dogs who are open to interspecies PLATONIC friendships? i am a friendly tuxie who likes to chill and have a good time. looking for big dogs (prefer outdoor) with stinky feet for smelling and cushy bellies for napping. Also I enjoy dog baths from giant tongues (kibble eaters only. canned dog food breath makes me gag). Excessive butt sniffers need not reply.

- Location: Pueblo, CO
- ID: 72348987

Community Ed Gymnastic Classes

Date: 2013-07-22 10:10AM EDT

(Reply to this post)

Former competitive parallel bars medalist-turned-coach, Puffball McSweeny, is now teaching all levels of gymnastics at the Catmunity Center. Whether you want to improve your balance in general or begin competing in cat parkour, Puffball McSweeny has a class for you. Schedules upon request.

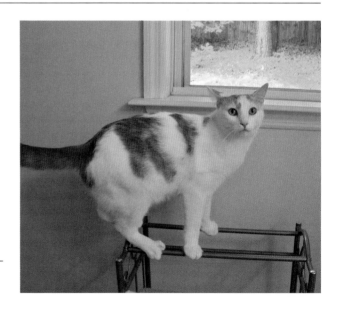

- Location: Catskills, NY
- ID: 783489379744

WAKE UP PEOPLE!!!

Date: 2012-10-25 5:12PM EDT

(Reply to this post)

Tigger Cunningham is a fraud! You can see right through this nut job! He says what he thinks you want to hear just to get your vote and then BAM! he LIES! Think he's really against crossbreed relationships? Look at this pic after he was caught with an underage Siamese in a public litter box. Not to be trusted! We do not want this cat in office!

- Location: Worcester, MA
- ID: 3298400980

Participants needed for timed, "flash mob-style" leg climbing, next month

Date: 2013-04-30 1:40PM CDT

(Reply to this post)

Has it been a while since you had a good leg climb? I know we "know better" now, but don't you all just miss the kittenhood days when we all clambered up the nearest pant leg? Join us in a flash mob-like mass event—we're trying for participation from every house with a cat and at least one leg. One for all and all for one. Hit me back and I'll send date and time.

- Location: Tuscaloosa, AL
- ID: 9384983033

Now Hiring: Exotic Dancers at Chasing Tail

Date: 2013-06-08 1:16AM CDT

(Reply to this post)

No experience necessary, but short audition required.

Applicants must have trim abs—no poochy bellies, please. Ideally have some climbing, stretching, and scratching post moves.

Hiring all shifts.

Great tips, free low-carb kibble.

Bobtails, polydactyls, hairless, and declawed all encouraged to apply.

- Location: Chicago, IL
- ID: 8340739498

SCUMBAG ALERT!

Date: 2013-08-10 4:12AM CDT

(Reply to this post)

Stay AWAY from this D-BAG! He will STEAL your nip and TAKE your women!!! He cannot be TRUSTED!!! His name is FRISBEE, but also goes by the names Butterscotch, Frank, and Mr. Socks. He is a LOSER!! Consider yourself WARNED!!!!!!!!!!!!!

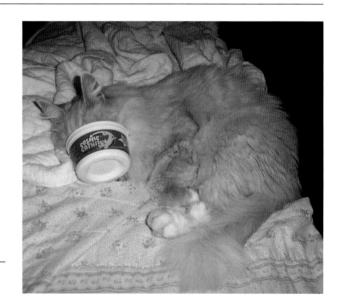

- Location: Rockford, IL
- ID: 7283876864

Private lessons: Humanese

Date: 2013-02-07 8:07AM EST

(Reply to this post)

Feline linguist offering private lessons in
Humanese. Learn important words and phrases
that will alert you to upcoming vet visits, human
vacations, and the onslaught of ham-handed
visitors with boundary issues at holiday gatherings.
Reasonable rates. GET TUTORED NOW (FYI:
neutered and tutored are not the same thing).
Call now.

- Location: Atlanta, GA
- ID: 9480843085

Closeted Country Club Boy Looking for Proper Lady Friend for Holiday Events

Date: 2012-11-30 5:46PM EST

(Reply to this post)

Hello. My name is Herbert and I am looking for a proper (spayed), well-behaved lady friend to accompany me to holiday parties. I am not out to my family yet, and need a date so I can keep up appearances at family functions. I will pay for everything, and you won't need to worry about my making any advances (obviously). Please send a photo, along with information about your hobbies and upbringing.

- Location: Newport, RI
- ID: 84543979794

###Crinkly Wrapping Paper 4 Free######

Date: 2013-01-02 4:23PM EST

(Reply to this post)

Used crinkly wrapping paper from chrismas

Medium shirt box size

As is. Some rips and chew marks. Sweet, sweet tape already pulled off.

Do you want this?

- Location: Athens, GA
- ID: 58997754

Anybody up for a start-up winter jingle ball league?

Date: 2013-01-26 9:19PM CST

(Reply to this post)

If you like balls as much as me LOL☺, you know it's even more fun to play with more than one cat and on the ICE!! I already have several interested cats and we just need a few more to start an official league. The pond behind Mocha's house is already cleared and I think I have enough balls LOL☺ for everybody. Plus, Anderson's Deli has "agreed" LOL☺ to sponsor us.

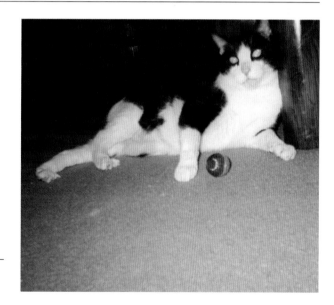

- Location: St. Cloud, MN
- ID: 849379553

Nobody's gonna "fix" me

Date: 2013-09-12 10:26PM CDT

(Reply to this post)

Help!! Need somebody to bust me out before those bastards strip me of my manhood next Monday.
Me: desperate and with easy access to the treat pantry. You: claws sharp enough to cut through screen and a desire for lots of liver snacks.

- Location: Nashville, TN
- ID: 23738648

whiskerslist > discussion forums > etiquette

(Reply to this post)　(Rate)　(Flag)

So last night I left my shoebox to take a leak and when I came back my rommate was in my damn box! He said an open box is open game but that's a bunch of BS. I mean, I was only gone a few minutes! What gives? <boxer123> 10/12/12 09:10

 Sorry, but I agree with your roommate. <mzmannerz> 10/12/12 09:13

 Me too. <tabbee2013> 10/12/12 09:20

 Kick his ass! <claws618> 10/12/12 09:15

 That's what I'm talkin' about. <frenchhisser> 10/12/12 09:34

 You guys are animals. <nmzmannerz> 10/12/12 09:40

 How big was the box? <ilikeboxes> 10/12/12 09:50

 I already said it was a shoebox. <boxer123> 10/12/12 09:54

 But what size shoebox? Slippers? Boots? <ilikeboxes> 10/12/12 09:58

 Why does that even matter?? <boxer123> 10/12/12 10:06

 I can fit in a 12 oz Whitman's Sampler candy box. <ilikeboxes> 10/12/12 10:14

 ??????? <boxer123> 10/12/12 10:08

 Just sayin. <ilikeboxes> 10/12/12 10:10

Looking for homesteaders to share my little piece of paradise

Date: 2012-11-19 1:10PM EST

(Reply to this post)

Sick of your little matchbox of a litter box?
Take a look at MY litter box! Join me for a startup
colony here in beautiful Key West. There's plenty
of fresh seafood, drunks to roll, and room for
everybody in this big beautiful giant cat box by
the sea! All are welcome, but send pic before I say
yes for sure.

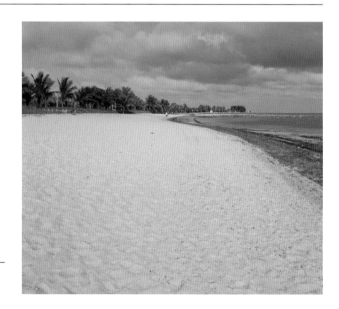

- Location: Key West, FL
- ID: 83497937743

My poop is award winning

Date: 2013-08-10 2:19PM CDT

(Reply to this post)

Your plants will love my nutrient-rich poo. I eat an organic raw food diet. One client's acorn squash won a blue ribbon at the Iowa state fair. I will travel within a five-mile radius. Tidy but generous deposits. You will not be disappointed.

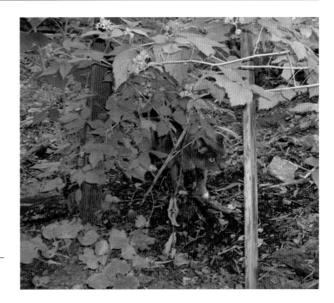

- Location: Mason City, IA
- ID: 89898734

Gain Self Confidence Through Hypnotherapy

Date: 2013-05-10 7:55PM EDT

(Reply to this post)

Are you tired of other cats stealing your toys and treats? Is lack of self confidence holding you back from defending yourself and speaking up? Isn't it time to do something about it?

Hypnotherapy is a safe and effective option. Message us for more information about our services, which also include help for weight loss, and anesthesia-free spay/neuters.

- Location: Toledo, OH
- ID: 28789287974

^^^^^bag in box combo!! barely used!!!^^^^^^^

Date: 2013-04-03 10:09PM EST

(Reply to this post)

what is better than a box and better than a bag?
how about a bag inside a box? it's a 2 for 1 deal. can
be used togethere or sepratly. this is so cool and I
hardly ever use it. need to sell. make an offer.

**did not remove catnip residue on bottom of the
box. your welcome.

- Location: Cleveland, OH
- ID: 6934082308048

Standing in line for the Porta-Litters at Nipapalooza . . . was that you?

Date: 2013-08-03 5:25PM CDT

(Reply to this post)

You: chatty Siamese with grain allergy. Me: twitchy Burmese with discolored fang and Garfield Sucks t-shirt. We were going to meet later at the nip-tent, but I was chasing the concert's laser lights and lost track of time. Hope you are seeing this!

- Location: Birmingham, AL
- ID: 58351546

Rental Cat for Hire

Date: 2013-03-01 8:04PM EST

(Reply to this post)

Love cats but either can't have, or don't want the responsibility of one 24/7? You can rent me! They call me the Wallinator.* I will sit in your lap while you watch sappy movies, pop over for an evening of post-break up cuddle therapy, and even parade in front of your annoying feline-allergic mother-in-law. Why worry about vet visits, daily litter box cleanings, and constantly scrubbing cat vomit out of your expensive rugs? Get your kitty fix on an as-wanted/needed basis!

With notice, can adjust heft and girth (15 to 21 pound range) to correspond with lap size. And that's a lotta Wallinator!

Overnights are extra, and I have an 11-day maximum (miss my peeps too much).

Prefer to be paid in ham. Strongly prefer.

* Or just Wally. Or Wally the Rental Cat. Or just Rental Cat.

- Location: Queens, NY
- ID: 9883479238

(Reply to this post) (Rate) (Flag)

Shoe <wordz> 04/10/13 07:18

 Stinky <clawd> 04/10/13 07:21

 Litter Box <wordz> 04/10/13 07:24

 Poop <clwd> 04/10/13 07:28

 Concentrate <wordz> 04/10/13 07:35

 Mating <clawd> 04/10/13 07:40

 Mating? <wordz> 04/10/13 07:42

 Oh, I thought that said "consummate." Sorry. <clwd> 04/10/13 7:45

Fleas <poet4u> 04/10/13 09:15

 Itch <chocchip> 04/10/13 09:17

 Claws <poet4u> 04/10/13 09:23

 Santa <chocchip> 04/10/13 09:28

 Fat <leo12> 04/10/13 09:36

 Lard <poet4u> 04/10/13 09:42

T-Bone <leo12> 04/10/13 09:46

The steak??? <chocchip> 04/10/13 09:52

My cousin. <leo12> 04/10/13 09:55

Litter <fangster> 04/10/13 10:10

 fart <jokerswild> 04/10/13 10:14

 cover <fangster> 04/10/13 10:18

 fart <jokerswild> 04/10/13 10:25

 crouch <leo12> 04/10/13 10:34

 fart <jokerswild> 04/10/13 10:38

 hey @jokerswild, enough with the fart <leo12> 04/10/13 10:42

 concentrate <fangster> 04/10/13 10:47

 fart <jokerswild> 04/10/13 10:51

 I'm done. <leo12> 04/10/13 010:55

Squirrels <poet4u> 04/10/13 12:10

 food <leo12> 04/10/13 12:13

 treats <princess#1> 04/10/13 12:22

 chicken <poet4u> 04/10/13 12:27

kibble <leo12> 04/10/13 12:29

crunch <poet4u> 04/10/13 12:34

shapes <princess#1> 04/10/13 12:37

fart <jokerswild> 04/10/13 12:45

Screw you <leo12> 04/10/13 12:51

Closed door<belly2012> 04/10/13 01:30

Bad <tabby2tone> 04/10/13 01:31

separation <wordz> 04/10/13 01:32

PANIC <tabby2tone> 04/10/13 01:33

anxiety <belly2012> 04/10/13 01:34

ABANDONMENT <tabby2tone> 04/10/13 01:35

This thread is bringing me down. <wordz> 04/10/13 01:36

For real. <belly2012> 04/10/13 01:37

For Sale: brown teddy bear "companion"

Date: 2013-04-10 12:19PM EDT

Reply to this post

Excellent cuddle buddy

Already broken-in by neutered male for "intimate moments"

Guaranteed squishy in all the right places

No visible stains

Perfect "bottom"

- Location: Augusta, GA
- ID: 34724987979

webcam models needed

Date: 2013-06-29 12:19AM CDT

(Reply to this post)

Need a few extra bucks for herb? We need male and female adult webcam models. No experience required but must have a flexible schedule, be open-minded, and have high-speed internet. Looks are not all that important, but must have a really great personality. (kidding)

- Location: Milwaukee, WI
- ID: 3847939797

$$$$$$$$$$$ Fur extensions SALE $$$$$$$$$$$$

Date: 2012-11-10 4:10AM CST

(Reply to this post)

Curious about fur extensions?

Want a new look for the holidays?

Try them now for

30% OFF!!!

Stop by Ramona's Beauty Parlor TODAY and mention THIS AD!!!!

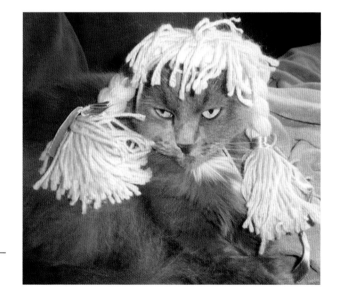

- Location: Mobile, AL
- ID: 2834893084

>>>>>WANT TO ALWAYS WIN AT UNO OR GO FISH?<<<<<

Date: 2012-11-29 5:45PM EST

(Reply to this post)

YOU CAN! SMOKY SHUBERT, WORLD RENOUNED
CARD SHARK WILL TEACH YOU DIFRENT STRATIGIES TO
WIN TIS GAME AGAINST ANYBODY.

********CARD COUNTING

********READING EXPRESIONS (EVEN POOKER FACES)

********BETTING 2 WIN

CONTACT ME I WILL TEACH U HOW TO DO IT.

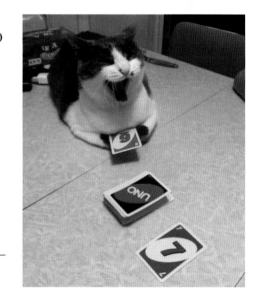

- Location: Erie, PA
- ID: 68348879374

Tired of worrying? Hire a Private Detective

Date: 2013-08-10 6:10PM PDT

(Reply to this post)

Sick of sleepless nights, wondering if he's behind the bushes with "her" again? Tired of fretting over not knowing who exactly is relieving themselves in your litter box or draining your water bowl? Worry no more. Our highly skilled investigators operate with the utmost confidentiality and discretion, and specialize in cheater investigations. Stealth is assured—THEY'LL NEVER KNOW WE'RE WATCHING, BUT YOU WILL.

- Location: Santa Barbara, CA
- ID: 97687686

PRIME RENTALS AVAILABLE AT HEAT VENT RESORT: "THE ASPEN OF NORTH DAKOTA"

Date: 2013-01-02 12:05PM CST

(Reply to this post)

LOOKING FOR THE PERFECT PLACE TO SPEND A FEW VACATION DAYS THIS WINTER? HOBNOB WITH THE FELINE UPPER CRUST AT VENTAGGIO, THE MOST EXCLUSIVE HEAT VENT RESORT IN NORTH DAKOTA. EACH 12" FORCED AIR VENT IS FLOOR LEVEL AND COMES WITH A LUXURIOUS RUG (IMPORTED FROM FARGO) AND AT-VENT FOOD SERVICE, INCLUDING LOCAL, ORGANIC VENISON JERKY AND CHEESE CURDS. ESCAPE FROM THE COLD AND PRESS YOUR BELLY AGAINST THE COZY WARMTH!!

- Location: Grand Forks, ND
- ID: 29804808

Lonely? Meet Fran

Date: 2013-02-22 10:43AM MST

(Reply to this post)

Fuzzy Fran for sale. Great for "keeping warm."
I had it for a year or so, but now I have a real
girlfriend and she is a jealous one. She said either
the duster goes, or she does, and well, I couldn't
argue with a sexy feline who has a tongue that won't
stop. But, if you find yourself between pussys,
Fuzzy Fran does the trick.

All offers entertained.

- Location: Twin Falls, ID
- ID: 9837876444

no Risk OPPORTUNITY

Date: 2013-07-01 8:10PM EDT

(Reply to this post)

With my no hype/no BS program (trademark pending), learn how I steal 62+ hot dogs a month from street vendors. Unlimited potential! Looking for five motivated individuals looking to change their life.

P.S. If u do not steal 62+ hot dogs per month within 3 mnths, you will receive everything u invested. Contact for more info . . .

Thanks,

Felix

- Location: New York, NY
- ID: 7738498989

Paw Fetish?

Date: 2013-04-03 6:19PM EDT

(Reply to this post)

Like paws? My pink paw pads are fresh from a romp outside. Want more of this? Message me. I have way more pics and ***MAY*** be willing to connect in person. Send me a normal pic of you (nothing gross) and let's chat.

p.s. my back paws have spotted pads. You like?

- Location: Fayetteville, NC
- ID: 28349792344

Master herbalist to teach class

Date: 2013-06-04 12:18PM EDT

(Reply to this post)

Snowflake, celebrity host of the cable access show,
Herb Your Enthusiasm, will be teaching master
classes at several local fields. Come learn which
herbs are the best for beauty treatments, summer
snacks, vomiting, or getting a light to full-on buzz.
Bring a friend and receive a coupon for 50%
off your next class.

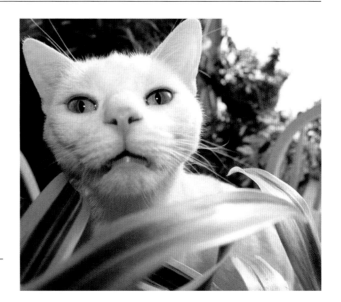

- Location: Knoxville, TN
- ID: 8342479834

I chew cords for you

Date: 2012-10-20 5:40PM EDT

(Reply to this post)

Mad at someone? For a fee I will chew through their computer cords, chargers, TV cords, etc. Just make sure they arent pluged in and I will do this for u. Humans hate that. Hint: if you have a dog it is easier to pretend it wasnt u. (no charge for that hint)

- Location: Tampa, FL
- ID: 39402804804

Reply to this post Rate Flag

I had kittens six weeks ago and am having trouble losing those last few pounds. Any suggestions? \<trying2lose\> 01/02/13 02:00

Have you tried the raw food diet? It helped me lose. \<rawgrrrl\> 01/02/13 02:12

Get off your fat a$$ and chase some mice or something. \<peepingtom\> 01/02/13 02:17

No need to be rude. \<rawgrrl\> 01/02/13 02:19

This is you. \<peepingtom\> 01/02/13 02:22

Hey! Go back to your dumpster. \<trying2lose\> 01/02/13 02:21

I'll say hi to your mom when I get there. \<peepingtom\> 01/02/13 02:22

Create beautiful tones with the doorstopper!

Date: 2013-04-14 4:19PM CDT

(Reply to this post)

In this beginner's class you will learn basic doorstop scales and a few simple tunes like Three Blind Mice and Chopsticks. All ages. Combined recital with beginner Vertical Blinds class to follow.

- Location: Owensboro, KY
- ID: 28394879

Saw you at the dump

Date: 2013-02-16 12:14PM CST

(Reply to this post)

Saw you at the city dump on Valentine's Day. You: Foxy gray lady with a white-tipped tail. Me: sleek, black, intact. We made eye contact while you were licking the inside of a plastic deli ham wrapper. It felt like there was a connection. If you felt it too, meet me around back of the sorting station at midnight tonight.

- Location: Waterloo, IA
- ID: 38472937492

!!avant-garde artist for hire!!

Date: 2013-03-26 7:19AM CDT

(Reply to this post)

Like what you see? I can recreate this in your house for a small fee. Other styles available, depending on ply, fiber thickness, and quilting pattern of medium.

- Location: Marfa, TX
- ID: 108849794

On-Site Paper Shredders Needed

Date: 2013-06-05 9:03AM PDT

(Reply to this post)

We provide onsite paper shredding to customers all over the city. If you love to chew all types of paper (including card stock) and have a flexible schedule, and don't excessively drool, contact us for an immediate interview.

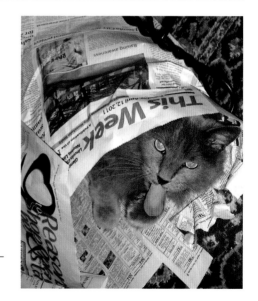

- Location: Seattle, WA
- ID: 887495898

Salami for stick of REAL (SALTED) butter

Date: 2012-10-02 9:20AM EDT

(Reply to this post)

I got a ½ pack of GOOD salami that I would
be willing to trade for a FULL stick of REAL butter.
NO FAKE STUFF OR NO TRADE!!! If it's
unsalted butter, I'll still trade, but I'm keeping at
least two pieces of salami.

- Location: Harrisburg, PA
- ID: 28783994

Got a big mouth? Have we got a job for you.

Date: 2013-08-10 6:10PM CDT

(Reply to this post)

Microchip identity theft is happening everywhere. What would happen if you got lost and suddenly no one could identify you because some crook hacked into your microchip? Help spread the word about this heinous crime and how to avoid becoming a victim.

We are looking for a talented public speakers to talk to groups of 10 to 20 on the subject of microchip identity theft and how they can protect their identities at a reasonable cost. Candidates will possess a flexible schedule and professional acumen. Perfect timing to start on the ground floor of a hot industry.

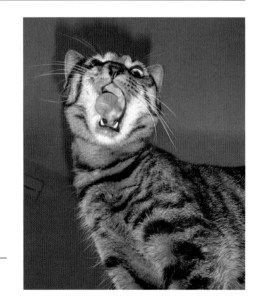

- Location: Sioux City, IA
- ID: 87673784

Cage-Dangle Meditation Classes

Date: 2013-03-01 1:03PM CST

(Reply to this post)

Cage-dangle meditation, made popular by Tibetan shelter cats, is now all the rage with felines everywhere. Combining this unique meditation posture with guided instructions for clearing your mind and releasing your bodily tension, you'll feel more relaxed than you've ever felt before. Don't think it's possible? Try your first class for free.

- Location: Madison, WI
- ID: 3748979784

Feline karate classes!!

Date: 2013-05-18 4:10PM CDT

(Reply to this post)

Learn the ancient art of feline karate at Moo Shoo's Karate Academy. I am a black-collar and learned from a real Japanese Bobtail master. My dojo is located underneath the bridge that's behind Kabuki Sushi.

- Location: Fairbanks, AK
- ID: 834979093

louisville whiskerslist > community > artists

male model availebale

Date: 2013-04-12 1:11AM EDT

(Reply to this post)

male model availebale. trying to jump start my careeer.
Ok with tatseful partial nudity and/or some licking poses. Teats ok.
no crotch shots plz.

• Location: Louisville, KY
• ID: 379879879

145

Free: Tissues!

Date: 2013-05-10 9:47PM EDT

(Reply to this post)

Premium, seasoned, one-week-old tissues
pulled from bathroom wastebasket. Slightly crispy
with some raggedy edges from chewing and
light batting around, but overall in decent shape.
If you like these, I will probably have more
available next week.

- Location: Virginia Beach, VA
- ID: 8340980980

Ironing Board Surfing Club

Date: 2013-01-18 6:00AM EST

(Reply to this post)

Hate water, but love to surf? Join us every Thursday at noon in Stripey's laundry room. Good prep for Iron Cat competition. No previous experience necessary. Boards provided. Bring your own cover.

- Location: Kalamazoo, MI
- ID: 37928982

Defamation of Character? Exploited? Victim of Kitty Pornography Ring? HELP IS JUST A CALL AWAY

Date: 2013-07-10 09:18PM MDT

(Reply to this post)

Are you nearly blind from the assault of the camera flash?
Are your photos being posted without your permission on Facebook, Twitter, and other public forums? Is a human misrepresenting herself by posing as YOU on social media sites? LOL? I think not. It's called identity theft.

Are demeaning videos being taken of you in ridiculous scenarios that defile your good name? Clearly a case of defamation of character.

I've won hundreds of exploitation, defamation of character, and other similar cases and will be happy to meet with you for a FREE CONSULTATION. Take back your life and right to privacy!

Mittens McMullen
Attorney at Law

"Extending My Claws . . .
So You Don't Have To."

Call for a FREE
Consultation

555-CLAW

- Location: Bozeman, MT
- ID: 783953879

Cleaning Service

Date: 2013-06-15 1:12PM CDT

(Reply to this post)

Cone of shame preventing you from properly cleaning your hindquarters? I do home visits. Sorry, no clay litter users. Dingleberries extra (you pay-per-dingleberry).

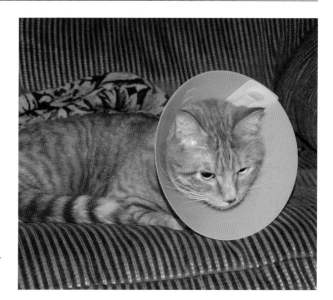

- Location: Auburn, AL
- ID: 98073778

~~~~SALE AT ROXY'S RUG HUT!!!~~~~

Date: 2013-04-18 2:10PM CDT

(Reply to this post)

THIS IS YOU (bored and uncomfortable)

THIS IS YOU ON RUGS (relaxed and happy)

ANY QUESTIONS?

EVERY CAT KNOWS TWO RUGS ARE BETTER THAN ONE! *****THIS WEEK ONLY!!!*****
STOP BY ROXY'S RUG HUT FOR OUR BIGGEST RUG SALE OF THE YEAR! CONSIDER YOUR
COMFORT. BUY MORE RUGS. MENTION THIS AD FOR FREE DELIVERY.

• Location: Chicago, IL
• ID: 8374923847

Reply to this post Rate Flag

Am I at one with the box or is the box at one with me? \<boxedin\> 02/07/13 4:15

 Hey man, you just did philosophy. \<MisterBoots12\> 02/07/13 04:15

 Just pondering . . . \<boxedin\> 02/07/13 04:25

 Great. Now I want a box. \<wtfmew\> 02/07/13 04:35

Where do kittens come from? \<gravy_guy\> 02/07/13 05:08

 Wrong forum, man. \<MisterBoots12\> 02/07/13 05:08

 Are you kidding me? \<lickerlou\> 02/07/13 05:16

FOR A SMALL INVESTMENT YOU CAN OWN YUR OWN NIP SHOP, STOCKED AND RENT PAID \<heymew\> 02/07/13 07:23

 I would raise chickens. \<MisterBoots12\> 02/07/13 07:35

 Great. Now I want a chicken. \<wtfmew\> 02/07/13 07:48

Drinking from the toilet: nature or nurture? \<nowandzen\> 02/07/13 10:05

 You think that's poetic, assbreath? \<lickerlou\> 02/07/13 10:12

 Great. Now I want to lick my ass. \<wtfmew\> 02/07/13 10:18

For the record, I say Nurture. <nowandzen> 02/07/13 10:15

Somebody taught you to drink human poop water? <lickerlou> 02/07/13 10:20

I come from a long line of toilet drinkers. Nature. <nowandzen> 02/07/13 10:23

I just know I like water, but not poop water. <lickerlou> 02/07/13 10:27

Great. Now I have to poop. <wtfmew> 02/07/13 10:32

I'm not sure I believe in the whole 9 lives thing. Who's keeping track anyway? Why not just live in the moment? <mzadventure> 02/07/13 11:06

I keep track. I lost my first life when I fell in the pool. I lost my second life when I got in a fight with a feral named Bruce. <HeyRocky> 02/07/13 11:09

@HeyRocky, nobody cares. I think the 9 lives are all a load of BS made up by fascists who want to define us and make us their puppets. <CapnTurd> 02/07/13 11:12

Then I lost my third life when a kid accidently locked me in the attic for three days. I lost my 4th life when I swallowed some string. <HeyRocky> 02/07/13 11:13

Enough already with the trip down memory lane, idiot! <CapnTurd> 02/07/13 11:16

Interesting how you keep track of it like that. Doesn't that make you worried about knowing when you think your life will end? <mzadventure> 02/07/13 11:15

Kind of. I get nervous, but I'm easily anxious. Oh, I lost my 5th life when I fell off the hardware store roof. <HeyRocky> 02/07/13 11:22

They want you to be nervous. Well played, Fascists. <CapnTurd> 02/07/13 11:25

How much wood would a woodchuck chuck? <think2much> 02/07/13 12:25

Poop <wtfmew> 02/07/13 12:33

CHEAP FELERECT® <u>CLICK HERE</u> <jshd7skjhs> 02/07/13 12:55

That depends. <iam> 02/07/13 12:35

On what? <think2much> 02/07/13 12:38

Did the woodchuck have a happy childhood? <iam> 02/07/13 12:41

He felt alone mostly. His father was killed in a logging accident. <think2much> 02/07/13 12:44

Woodchucks are delicious. <wtfmew> 02/07/13 12:44

Do you want to talk about something @wtfmew? You sound like you have a deep need for attention. What were your kitten years like? <iam> 02/07/13 12:47

Mmm. Gravy. <wtfmew> 02/07/13 12:49

Wanted: bouncer at Frisky Fred's Tavern

Date: 2013-07-10 3:19PM CDT

(Reply to this post)

Looking for large (15+ lb) tom, preferably feral, to bounce at rowdy bar. No background check required. Must have all claws and a full set of teeth.

- Location: Minneapolis, MN
- ID: 8374702809

Like-New Spotted Jingle Mouse Toy: $1

Date: 2012-10-19 9:12PM CDT

(Reply to this post)

Motivated seller!

Fun mouse! Excellent, like-new condition!

Large mouse/small rat size!

Felt ears and eyes, ribbon tail with intact bell!

Four whiskers on each side!!

Bonus jingle inside mouse!

- Location: Dubuque, IA
- ID: 87985675

Tortie Looking for Hot-blooded Tom for Casual Sunbathing . . . or More

Date: 2013-05-10 3:11PM PDT

(Reply to this post)

Like what you see? Looking for a possibly regular sunbathing hookup—open to hosting and/or coming to you (if your house, then no elecric mixers, vacuum cleaners, or hairdryers in use during our visit please). Show me your "sunny spot" and I'll show you mine. If we make a connection, am open to top/bottom cleaning or possibly more. Must be ringworm and earmite free. Please reply with Sunbathing in subject line to weed out spam.

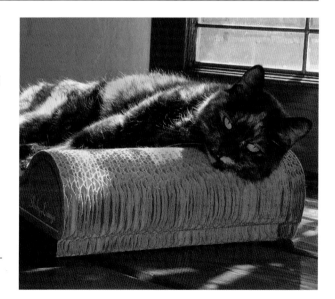

• Location: Orange County, CA
• ID: 4367838768

~ VACANCY IN IN-DEMAND KITTY VILLAGE!! ~

Date: 2013-02-10 2:10PM EST

(Reply to this post)

Stop in and take a look at this GEM of an apartment building in the HEART of DT Ithaca. Ground floor units available NOW!!! Experience all the LUXURY that two square feet of cardboard has to offer. Open floor plan, no obvious chew marks or hairball stains, and CLEAN!!

Mention this ad and get one month FREE membership to all-you-can-drink nearby city water fed toilet.

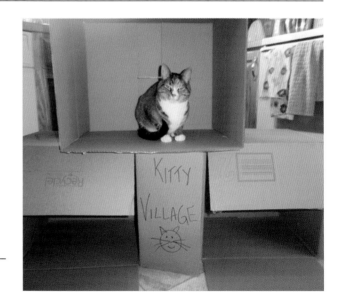

- Location: Ithaca, NY
- ID: 73482997

Assembel products at home: big $$$

Date: 2013-04-10 12:19PM MDT

(Reply to this post)

Want a job that will work with YOUR nap schedule? Look no farther. There are lot's of companys that offer big $$$ but we GUARENTEE the most CURRENT job opps and biggest PAYOUTS. Our work at home guide is filled with home assembe jobs that are LEGIT!

You can assemble:
Scratching posts
Wand toys
Catnip mice
Feather "burds"
Cat tunnles
And MORE!!

Reply now for more information on how to purchase the Home Assembly Guide for the special price of $2.99. You will get a full refund if you refer two of you're friends.

- Provo, UT
- ID: 8470583054

DIY kit for Lazee Catz™ mouse-catcher

Date: 2013-08-15 9:12AM PDT

(Reply to this post)

Lazee Catz™ mouse-catcher made with empty litter box, poop scoop, string, and your choice of cheese

Works 86% of the time

You lounge, eat treats, lick your butt, and let **Lazee Catz™** do all the work

Good deal: $2.50 (cheese not included)

ACT NOW GET A SECOND ONE, PLUS EXTRA SPOOL OF STRING ABSOLUTELY FREE!

- Location: Portland, OR
- ID: 84509389058

MOUSE CATCHER!

MOUSE

YOU

© LAZEE CATZ ™

Used Pink Mouse for ???

Date: 2012-11-21 5:45PM CST

(Reply to this post)

Tail and ears are slightly chewed but still in pretty good condition

One missing eye and no whiskers on right side

Still jingles some

Smells a little bit like pee

Will entertain all offers of bell or feather toys

(No catnip, please, I'm allergic)

- Location: Dubuque, IA
- ID: 87985675

Fang Shui Consultant

Date: 2012-11-10 6:15PM PST

(Reply to this post)

Let me help you get the Chi flowing in your home. The direction you face while you poo, and locations where you eat, sleep, and hack up hairballs make all the difference in bringing health, balance, and happiness into your life. Also learn to erase bad Chi by clearing energy blockages created by humans. Contact me for a free consultation.

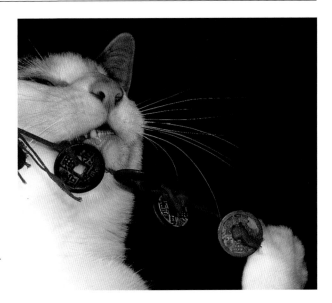

- Location: Ojai, CA
- ID: 09384038204

CASH for ur whiskers and claw clippings

Date: 2013-03-19 6:23PM EST

(Reply to this post)

i need unbroken whiskers and claw clippings for my exclusive collection. all colors and sizes. let me know and i can pick them up, no problem. Cash on the spot.

- Location: Frederick, MD
- ID: 2390893849

Smitten with chatterbox

Date: 2013-08-02 12:15PM PDT

(Reply to this post)

You were climbing the screen door, chattering at the suet feeder, and I was admiring you from under the patio chair. Watching your snow white belly pressed against the ragged screen drove me crazy! You glanced at me and then quickly turned back to the feeder and kept chattering. I know the chances are slim, but if you are interested, meet me at the screen door tomorrow at 8 am.

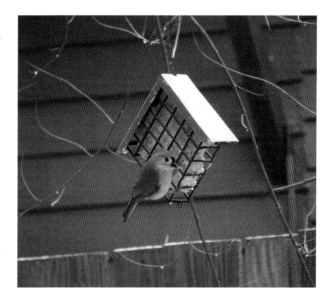

- Location: Lake Tahoe, NV
- ID: 98372497093804

used Q-tip for ????????????

Date: 2012-11-02 1:19PM MST

(Reply to this post)

found Q-tip with deliciousness on each end. ready to entertain you're offer of slim jim or american cheese wrappers, or something comperable.

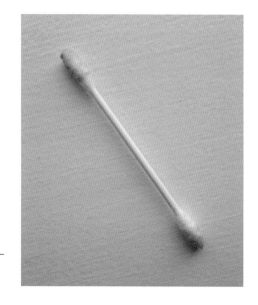

- Location: Prescott, AZ
- ID: 638278004

5-year-old single mom seeks neutered male

Date: 2012-10-18 2:10PM PDT

Reply to this post

Single mom to four adorable kittens looking for a responsible, NEUTERED male who loves the idea of instant family, to help with kitten care duties and the occasional night out for dumpster-diving at the beach. Must be a good role model and FIV-free.

- Location: Santa Monica, CA
- ID: 543216544

Reply to this post Rate Flag

Do any of you ever see weird stuff when you are just hanging out, grooving into a really good stare? Like shapes and shadows . . . you know, ghostly stuff? I didn't think I believed in that supernatural junk, but I'm starting to change my mind. \<used2bskeptic\> 04/12/13 5:07

> Dude, that's real. I can't even begin to tell you about the weird stuff I've seen when I'm just staring at the wall. \<xfilesfan\> 04/12/13 05:17

> What did the shape look like? \<mystikmanx\> 04/12/13 05:26

>> Kind of shadowy . . . dark and eerie. \<used2bskeptic\> 04/12/13 05:30

>>> I saw something dark and eerie once . . . in the litterbox. \<lickme123\> 04/12/13 05:32

>>>> Not funny. \<mystikmanx\> 04/12/13 05:34

> Bro, lay off the catnip. \<lickme123\> 04/12/13 05:18

> My cousin can predict the death of humans. Seriously. \<krystal2\> 04/12/13 05:26

>> I predict your cousin is a d-bag fraud. \<lickme123\> 04/12/13 05:32

>> Don't you believe there are mysteries we can't explain? \<krystal2\> 04/12/13 05:34

>>> I've got your mystery right here. \<lickme123\> 04/12/13 5:36

> I once saw the ghost of one of my littermates at the back door. \<iamsiamese\> 04/12/13 05:45

Wanna see ME at your back door? Ha. <lickme123> 04/12/13 05:56

I totally believe you. My cousin says he can feel energy too. <krystal2> 04/12/13 05:58

Wanna feel MY energy? <lickme123> 04/12/13 06:02

Blocking you now. <krystal2> 04/12/13 06:05

Go ahead. I'll return. Just like tick season. <lickme123> 04/12/13 06:08

Anyone have any Frontline Plus?? <krystal2> 04/12/13 06:09

Oh, I'll let you jump to the front of the line. Come on over. <lickme123> 04/12/13 06:10

UGH! <krystal2> 04/12/13 06:11

Who wants this mouse?

Date: 2012-12-31 2:00AM CST

(Reply to this post)

Pink spotted mouse toy with zero tail or eyes

Ears frayed but may be completely gone by the time you get here

Stinky, but maybe you like that

Come and get it

- Location: Dubuque, IA
- ID: 993642868

12-Step Group: Cord Chewers Anonymous

Date: 2013-08-01 1:45PM EDT

(Reply to this post)

Closed meeting at Oreo's house for those with a desire to stop chewing household cords or those who think they may have a problem with cord-chewing. If you are concerned about your habit, please attend this Saturday morning group. String swallowers and dental floss junkies welcome too. Contact for more details.

*GAK-Anon meets at same location; please enter through kitchen window in order to avoid their meeting.

- Location: Gainesville, FL
- ID: 3478698686

Siamese twins fetish

Date: 2013-04-13 4:30PM EDT

(Reply to this post)

Six-yr old tuxedo male, well-endowed with silky black tail, looking to hook-up with Siamese twins for discreet fun. Must like dirty chatter and supply own harnesses and leashes. Pedigree papers required.

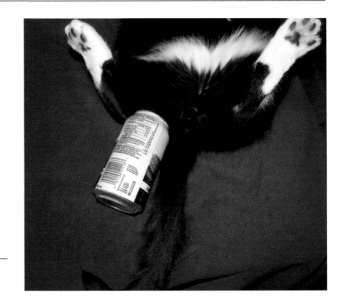

- Location: Lansing, MI
- ID: 8304900

Free: medium-size Amazon.com shipping box

Date: 2013-01-29 1:45PM EST

(Reply to this post)

Great box, like new.

Used for occasional napping, hiding, peeking, and peering.

Oblong shape, could hold two cats (three, but it would be tight).

You pick up.

- Location: Chattanooga, TN
- ID: 8400490580

Reply to this post Rate Flag

Any black/white females interested in a skunk-cat relationship? <lepew4u> 07/01/13 02:15

What?? What are you, some kind of freak? <str8kat> 07/01/13 02:20

Don't even give him the energy. He's just a troll. <wskr5> 07/01/13 02:23

Don't judge just because you do not understand. <lepew4u> 07/01/13 02:26

You mean like Pepé Le Pew? Me-Ow! <skunkluv> 07/01/13 02:32

Oui, oui, Mademoiselle! I am looking for some fun-play-time where you play hard-to-get and I chase you. Voulez vous? <lepew4u> 07/01/13 02:35

What in the name of Bast is going on here? This is supposed to be a hunting forum! <wskr5> 07/01/13 02:40

Well, maybe *I* want to be hunted! <skunkluv> 07/01/13 02:43

This belongs in the cross-species forum! <str8kat> 07/01/13 02:45

Message me, you hot little polecat! <lepew4u> 07/01/13 02:48

GAK (tosses up Friskies) <str8kat> 07/01/13 02:50

Help Wanted: dog seeking cat to help mark items

Date: 2013-03-19 3:16PM CST

Reply to this post

Dog tired of household cats stealing all his toys. Need an XL or XXL outside cat to meet him at local park and mark his stuff so thieving cats will stay away. Will pay handsomely with choice of toys and treats, or return favor in kind.

- Location: Fort Worth, TX
- ID: 89492374927

Class: Crafting with Hairballs

Date: 2012-11-18 2:10PM CST

(Reply to this post)

Time to make use of those pesky hairballs!
Don't let them be thrown away, or eat them again
(trust me on this one). Instead, in just two short
weeks, you can become an expert in sculpting
fabulous trinkets, toys, pillows, booties, batty balls,
and other keepsakes with your collected hairballs.
You'll leave this two-week class with five completed
projects . . . just in time for Christmas! Class
runs every night from 12/1 to 12/14 from 7pm til
whenever. Must supply own material so
start gacking now!

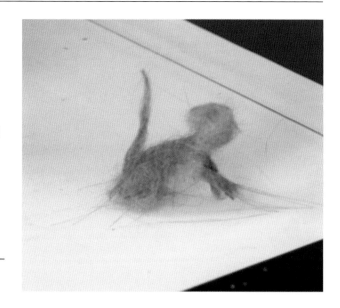

- Location: Austin, TX
- ID: 8372794803

Cheap Nipple Piercing

Date: 2013-02-01 7:10PM CST

(Reply to this post)

Clean, safe environment

$10 for first 4 nipples, $5 for each additional

$25 special for all 8 nipples

Price includes jewelry. Connector chain available for purchase as well.

- Location: Lake Charles, LA
- ID: 9028479879

OCD cat will bathe you for free

Date: 2013-01-18 3:19AM EST

(Reply to this post)

Think you are a thorough bather? You've never met me. I've got the roughest tongue in town. Let me get you cleaner than you've ever known. My family calls me the feline detailer. I bathe myself for hours. I'm not kidding. I lick each paw a minimum of ten times after each bat at a toy and will only "go" in brand-new litter. Full cleanings typically take a minimum of three hours. Must be at least ten months old. Can arrange house calls, or discreet locations. Happy customers, but no "happy endings."

- Location: Greenville, SC
- ID: 98473927497

Are you as funny as you think you are? Try standup!

Date: 2013-07-12 12:03PM EDT

(Reply to this post)

Looking for standup comics to perform at comedy club in the oak tree behind Stinky's garage. Amateurs welcome. Open mic nites on Thursdays. Free drinks from the neighbor dog's dish.

"What's the difference between a smart dog and a unicorn? Nothing. They're both fictional." If this is your idea of funny, do not apply. (that means you, @intactcat69 from the Joke board)

- Location: Valdosta, GA
- ID: 276899764

Reply to this post Rate Flag

Did you hear about the cat who swallowed a ball of wool? She had mittens! <lolololcat>
11/09/12 08:08

> Haha! <jester12> 11/09/12 08:12
>
> You're moms a ball of wool. <smoochy> 11/09/12 08:15
>
>> That's not even funny. <jester12> 11/09/12 08:20
>>
>>> You're moms not even funny. <smoochy> 11/09/12 08:25
>
> What newspaper do cats read? The mewspaper. <nipsykat> 11/09/12 08:20
>
>> Hilarious! <lolololcat> 11/09/12 08:22
>>
>>> You're moms a newspaper. <smoochy> 11/09/12 08:28
>>>
>>>> Go away freak. <nipsykat> 11/09/12 08:28
>>>>
>>>>> You're moms a freak. <smoochy> 11/09/12 08:30
>>>>>
>>>>>> I said go away. <nipsykat> 11/09/12 08:32

You're . . . mom . . . <smoochy> 11/09/12 08:40

Why did the Persian climb the chain link fence? To see what was on the other side! <spottyone>
11/09/12 08:13

I get it. Because Persians are stupid. <nipsycat> 11/09/12 08:15

You're moms sttupid. <smoochy> 11/09/12 08:22

Hey! I'm a Persian and find that offensive. <hottail> 11/09/12 08:16

You're moms offensive. <smoochy> 11/09/12 08:19

It was a joke. Welcome to the JOKE BOARD. <spottyone> 11/09/12 08:20

You're moms a joke board. <smoochy> 11/09/12 08:24

I'm going to report you. <spottyone> 11/09/12 08:35

I just reported you're mom <smoochy> 11/09/12 08:44

What's the difference between a smart dog and a unicorn? Nothing. They're both fictional. <intactcat69> 11/09/12 08:26

Uh, that's not all that funny! <lolololcat> 11/09/12 08:29

You're moms a unicorn. <smoochy> 11/09/12 08:30

Really? I can't stop laughing! Get it? Get it?? <intactcat69> 11/09/12 08:33

I'm not feelin' it . . . <lolololcat> 11/09/12 08:40

I'm feelin' you're mom. <smoochy> 11/09/12 08:44

GET OFF! <intactcat69> 11/09/12 08:55

You're mom just got off this <smoochy> 11/09/12 08:56

Basement rental, CHEAP, lots of nooks for hiding

Date: 2013-02-09 5:19PM PST

(Reply to this post)

Dark stinky basement, 500 sq. feet

Lots of holes in walls leading to cool, dark, hidey spots

Simple litter area with nearby rug for comfortable, immediate cleaning

Bonus: daily rodents and lots of those thingies with a million legs

Disclosure: Previous tenant had fleas and chronic ringworm

- Location: Reno, NV
- ID: 5468713

Free: Brown paper Target bag

Date: 2012-12-19 1:05AM PST

(Reply to this post)

Used once for catnip
Love this bag, but my head gets stuck in the handles
Slightly crinkled
Small tear on one side
Nice brown color
Great for hiding
Can fit one large or two small cats
Folds for easy transport

- Location: Modesto, CA
- ID: 835098948508

Looking for nontraditional relationship

Date: 2013-06-10 6:52AM EDT

(Reply to this post)

My name is Boris. I am a feli-curious raccoon looking for a connection. I enjoy dining outdoors and digging through rubbish, too. I also enjoy lively nightlife. Open to male or female. Let's see what happens.

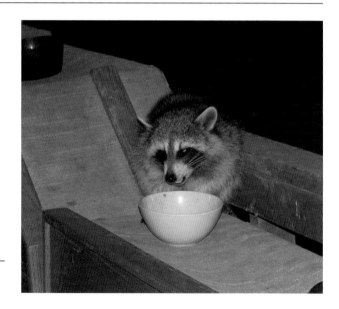

- Location: Charlotte, NC
- ID: 73423987497

Angry about Destruction of your Private Property? Suffering from Litter Box induced PTSD? HELP IS JUST A CALL AWAY

Date: 2013-03-02 10:12PM MDT

Reply to this post

Has your personal litter been taken (stolen) without your permission and now you're forced to relieve yourself in what they're calling "corn" or "wheat"?

Experiencing pain and suffering due to your litter box being forgotten for a day or more and you're left to defecate on top of your own defecation?

I've won hundreds of theft, destruction of private property, and toileting PTSD cases, and will be happy to meet with you for a FREE CONSULTATION.

- Location: Bozeman, MT
- ID: 783953879

(Reply to this post) (Rate) (Flag)

Stupud human keeps putting hats on me. Im ready to peee all over her cloths. Advise? \<hatzoff\>
08/17/13 02:15

> I don't mind a nice cape and beret now and again. What's the prob? \<travis111\> 08/17/13 02:23

>> Not ony do I look RIDICULUS, it hurts my ears. \<hatzoff\> 08/17/13 02:23

>>> I'll bet you look nice. \<travis111\> 08/17/13 02:28

>>>> Dude. Look. \<hatzoff\> 08/17/13 02:35

Damn, I'm sorry (nice balls). <travis111> 08/17/13 02:38

**COLOMBIAN CATNIP {{CHEAP}} <u>CLICK</u> <kdjf90ji9> 08/17/13 02:23

Do you have your claws? You need to go all feral on her ass. She'll think twice next time <stripe striker> 08/17/13 02:25

I'd rathre just pee on the hat. <hatzoff> 08/17/13 02:28

But she made you look like a freaking moron. <striperstriker> 08/17/13 02:32

I'm not relly violeant in that way. <hatzoff> 08/17/13 02:37

Maybe you ARE a moron. Wear the hat, moron. <striperstriker> 08/17/13 02:39

Nice balls. <travis111> 08/17/13 02:43

He ain't got no balls. <striperstriker> 08/17/13 02:45

Talent scout looking for fresh faces for potential YouTube viral videos!!

Date: 2013-05-10 4:12PM PDT

(Reply to this post)

Can you slide across a linoleum floor on your belly and land in a paper grocery bag? Play a musical instrument? Imitate Human sounds or make loud "nom" noises while eating? Can you eat with chopsticks? Do you have a super-funny/angry/sad/grumpy dramatic look? You may be a candidate for a new talent agency looking to create funny cat videos! Viral cat videos are all the rage! Why let other cats get all the YouTube hits? Please send an audition video demonstrating your special funny "skill," and we will contact you if you make the cut. Special consideration for cats who nurse animals of other species or can ride on Roombas or the backs of other animals.

- Location: Orange County, CA
- ID: 7349239498

If you like tuña-coladas . . .

Date: 2013-02-02 12:02PM PST

(Reply to this post)

If you like tuña-coladas, and gettin' out of the house,

If you're not into 9-Lives, and you want a fat mouse,

If you like garbage cans at midnight, chewing through wrapper tape,

I'm the tom that you've looked for, write to me and escape.

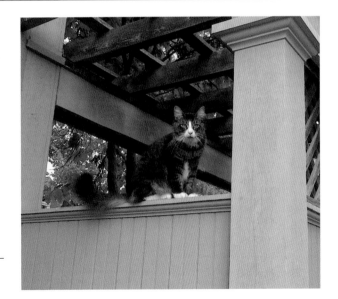

- Location: Yakima, WA
- ID: 83492739479

Let your stress melt away.

Date: 2013-02-28 9:12PM EST

(Reply to this post)

Does this look like you? Are you stressed, cranky, and just need a break from those bosomy groping humans, needy kittens, or that neighborhood dog who constantly slobbers all over you? Life is rough. You need some "me" time, don't you? Come into Beverly's Beauty Oasis for a little pampering. We'll brush you, trim your nails, feed you organic dried poultry treats, and scratch under your chin til you're purring like a kitten.

**Belly scratches available for cats that don't bite when their belly is touched.

- Location: Vermont
- ID: 649483028403

Lost: three pairs of mittens

Date: 2013-06-10 8:08PM CDT

(Reply to this post)

Three kittens must locate or no pie will be had. Mittens are homemade with green, pink, and blue mouse designs and cherry pie stains. Many tears shed. Any help is appreciated.

- Location: Madison, WI
- ID: 54642356

Free: Lot of three holiday shirts

Date: 2013-06-10 11:13AM CDT

(Reply to this post)

Someone please take these dumbass shirts so my human will stop making me wear them. These would make great litter box liners. I will deliver. Absolutely no returns.

- Location: Galveston, TX
- ID: 743792974

(Reply to this post) (Rate) (Flag)

Human suddenly started closing dresser drawers I like to sleep in. I've got the shakes, man. I need a drawer. \<getinurdrwrs\> 02/04/13 08:12

> Breathe and remember the first step. You are powerless over the drawer. \<12stpz\> 02/04/13 08:20

>> I know, I know. It's been two days and I'm starting to look for something, anything that gives me that drawer high. \<getinurdrwrs\> 02/04/13 08:25

> How about a box? \<foxyboxy2\> 02/04/13 09:10

>> Not the same, dude. I need the clothes. \<getinurdrwrs\> 02/04/13 09:14

>>> Pics of hot tabbies in heat <u>click here</u>. \<fuzzynutz\> 02/04/13 09:29

> It took me about two weeks for total drawer sobriety. Be patient. \<cleancat333\> 02/04/13 08:58

>> Any tips? \<getinurdrwrs\> 02/04/13 09:04

>>> Sleep. Lots of sleep. And maybe a laundry basket. \<cleancat333\> 02/04/13 09:14

>>>> Thanks, man. \<getinurdrwrs\> 02/04/13 09:20

>>>>> No prob. I totally feel ya. \<cleancat333\> 02/04/13 09:28

>>>>>> Hot pics of hot tabbies in heat <u>click here</u>. \<fuzzynutz\> 02/04/13 10:18

>>>>>>> A$$hole troll. \<cleancat333\> 02/04/13 10:25

Napping exhibitionist looking for someone who likes to watch

Date: 2012-12-10 3:11AM EST

(Reply to this post)

Me: attractive, clean, and short-haired black and white female who likes to nap in glass bowls

You: curious voyeur who wants to hide and watch as I conform my body to a sexy glass bowl and sleep for hours.

I easily sleep for two hours at a time but change positions often, offering a variety of views (including some rear) so let's work out a time and I'll leave the kitchen window open. No more than one watcher at a time.

- Location: Cleveland, OH
- ID: 723487368468

Opener For Hire

Date: 2012-11-23 11:02PM AKST

(Reply to this post)

Looking for a Thanksgiving feast? Hire me to raid the kitchen and pantry! I created a device (patent pending) that I can open any fridge, or any door with. Latches, doorknobs, sliders—no problem. I can get u great foods. you just tell me what you want and I will get it for you. Or, I can get it open for you to take it from there.

contact for rates.

p.s. eventually I might sell my device—make an offer.

- Location: Anchorage, AK
- ID: 495034805834

One-Day Workshop: Master the Art of Looking Away Quickly When Photographed

Date: 2013-06-18 8:52PM EDT

(Reply to this post)

It's an art, really . . . knowing just the moment to turn your
head and look away as the shutter clicks. Come spend the
day with fellow cats and learn the many methods for avoiding
that perfect photo. If time allows, we will also cover the basics
of glow-eye. Bring or catch your own lunch (can openers
and water provided).

- Location: Hudson Valley, NY
- ID: 9950828453950

50 Great Hiding Spots

Date: 2013-07-29 10:08AM CDT

(Reply to this post)

One of this year's best-selling books about hiding! Has your human figured out your best spots? Tired of being manhandled when you just want to sleep? Absolutely have to avoid a trip to the vet, or other car ride? Look no further! In this handy and easy-to-read book by renowned hider, Mittens Leibowitz, you'll get tips on some of the best untapped hiding spots found in most houses and apartments . . . even studios! Learn to think outside the box! Cost: $3.50 printed copy (plus shipping) or $2.00 instant download.

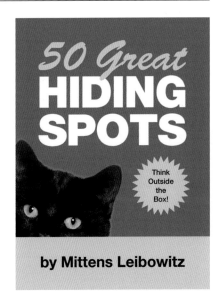

- Location: Memphis, TN
- ID: 73428648902

Is this you????

Date: 2013-08-03 6:52AM EDT

(Reply to this post)

I saw you staring in my window when I was bathing. I liked it, but you ran off before I had the chance to make your acquaintence. My trail cam snapped this pic of you. Come back at 10 tonight. I'll be bathing again, collar off . . .

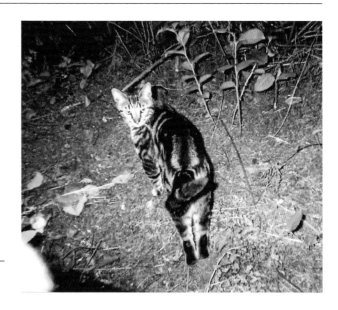

- Location: Lexington, KY
- ID: 93849993422

los angeles whiskerslist > gigs > talent gigs

"Six Cats, One Box"—Casting Call

Date: 2013-02-19 6:16PM PST

(Reply to this post)

Currently casting for a new reality show, "Six Cats, One Box." Looking for ten cats (ages 1–2) to share a tricked-out cat condo and one litter box in generous studio apartment for twelve weeks. Specifically interested in: unruly ferals, unspayed cats willing to keep situation a secret until final weeks, FIV/FeLV-positive cats, cats with hairball issues, droolers, non-buriers/un-buriers or other litter-box issues, good/bad hunters, cheap kibble addicts, excessively loud purrers, tripods, and overweight felines. Must be social and willing to live in close quarters (surrounded by cameras) with personalities of all types.

Please send photo and short paragraph about why you should be cast.

- Location: Los Angeles, CA
- ID: 54654613

Found: gray catnip mouse with chewed-off tail

Date: 2013-08-02 9:05AM CDT

(Reply to this post)

Ratty-looking, gray catnip mouse with chewed-off tail found under the sofa at Lady Tabitha's House of Tarot and Paw-Reading. Lady Tabitha has a vision of a dilute-tortie owner with green eyes, but doesn't get a name.

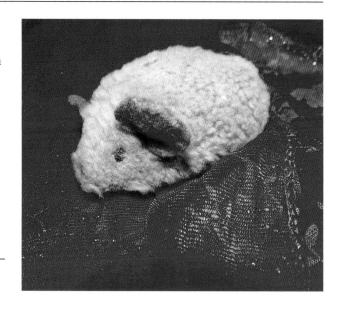

- Location: New Orleans, LA
- ID: 1458954

Hoarder cat needs help clearing out—you get choice of stuff

Date: 2013-02-10 9:10AM EST

(Reply to this post)

My brother is a hoarder, and I want to stage an intervention. Under the couch is jam-packed with unwrapped catnip toys, crumpled paper balls, pens, milk lid tabs, and shampoo bottle caps (don't ask). He is finally open to assistance as he can no longer find his prized, mint-condition 1978 Alberto VO5 cap (don't ask). In return for your help clearing out stuff, you will receive your choice of toys and shampoo caps (except the'78 VO5, of course). Because this is a private family matter, I'm requesting complete confidentiality from everyone involved.

- Location: Cincinnati, OH
- ID: 749879379054

Need Help Writing Whiskerslist Posts?

Date: 2013-04-29 1:03PM CDT

(Reply to this post)

Want a great post that will get noticed? Hire ME to write it for you. I know I am young, but I've had my own e-mail, Facebook page, blog, twitter, and pintarest accounts since I was 12 weeks old. I'm a great writer and have already helped lots of others sell their used items and find dates. I'm really not supposed to be doing this so if you recognize me, please don't tell my mom. She thinks I'm at my napping lessons. Thx.

- Location: Houston, TX
- ID: 9534080805

Photo Credits

9. © Sarah Gay
11. © Angie Bailey
13. © Angie Bailey
15. © Nicky Westbrook
16. © Angie Bailey
17. © Ashley Fritsch
18. © Angie Bailey
19. © Nicky Westbrook
20. © Tamar Arslanian
21. © Angela Bellinger
23. © Sorche Fairbank
27. © Nicky Westbrook
28. © Patti Bolson-Robinson
29. © Robyn Van Sant
30. © Angie Bailey
31. © Cathy Bowers
32. © Donna Bailey
35. © Kathryn Herman
36. © Angie Bailey
37A. © Glenn Dowell
37B. © Sandy Shelton

38. © Duane Orlovski
40. © Sorche Fairbank
41. © Sorche Fairbank
42. © Teri Thorsteinson
44. © Duane Orlovski
45. © Carmelynn M. Cole
49. © Kathryn Herman
51. © Angie Bailey
52. © Sorche Fairbank
53. © Sorche Fairbank
55. © shutterstock.com/
Spectruminfo
56. © Duane Orlovski
57. © Kari Achenbach
58. © Carmelynn M. Cole
59. © JaneA Kelley
60. © Sorche Fairbank
62. © Angela Bellinger
63. © Marina Dickey
64. © Nicky Westbrook
65. © Tamar Arslanian

67. © Alex Fairbank
68. © Nicky Westbrook
71. © Caren Gittleman
77. © Dan Power
78. © Kari Achenbach
79. © Flickr.com/roberthuffstut-
ter's photostream
80. © Angie Bailey
81. © Carole F. Prior
83. © Sorche Fairbank
84. © Marina Dickey
85. © Robin A.F. Olson
86. © Robin Lynn Mitchell
87. © Angie Bailey
88. © Todd and Amy Grady
90. © Angela Bellinger
92. © Laura Bennett
96. © The Froemkes
97. © Angie Bailey and
Marina Dickey
100. © Angie Bailey

Are you sure you want to
log off of whiskerslist?